SARAH MICHELSON

MODERN DANCE

David Velasco

Series editor: David Velasco

The Museum of Modern Art, New York

The publication series Modern Dance is made possible by MoMA's Wallis Annenberg Fund
for Innovation in Contemporary Art through the Annenberg Foundation.

Produced by the Department of Publications, The Museum of Modern Art, New York
Christopher Hudson, Publisher
Chul R. Kim, Associate Publisher
David Frankel, Editorial Director
Marc Sapir, Production Director

Edited by Rebecca Roberts
Designed by Joseph Logan and Rachel Hudson
Production by Hannah Kim
Printing and binding by Ofset Yapimevi, Istanbul

This book is typeset in Futura and Bembo. The paper is 120 gsm Amber Graphic.

Published by The Museum of Modern Art
11 West 53 Street, New York, New York, 10019-5497
www.moma.org

Library of Congress Control Number: 2017931848
ISBN: 978-1-63345-008-0

Distributed in the United States and Canada by Artbook | D.A.P.
155 Sixth Avenue, 2nd floor, New York, New York 10013
www.artbook.com

Distributed outside the United States and Canada by Thames & Hudson Ltd
181A High Holborn, London WC1V 7QX
www.thamesandhudson.com

Printed and bound in Turkey

CONTENTS

FOREWORD

The Museum of Modern Art's long relationship with dance and performance may be among the lesser-known parts of its history. As far back as the 1940s, the Museum had a Department of Dance and Theater Design, if only for a few years; various experiments followed from the 1950s onward, as Kathy Halbreich, the Museum's Associate Director and Laurenz Foundation Curator, describes in her introduction to this book. This occasional but serious interest was regularized in 2009 with the expansion of the Department of Media Art into the Department of Media and Performance Art. Founded by Chief Curator Klaus Biesenbach and now led by Chief Curator Stuart Comer, the department has developed a dynamic program of dance and live arts, articulating the Museum as a platform for performance in the context of the collection and the broader history of modern and contemporary art.

In its focus on performance, MoMA has anticipated an interest now shared by many museums around the world. This shift has entailed some fairly dramatic rethinking: historically, museum architecture has not been designed for performance or dance, and the museum collection must be reimagined if it is to embrace the human body moving in space and time. At MoMA we have begun to address these issues. This process, ongoing and incomplete, will be greatly advanced with the construction of a space tentatively called "The Studio," a priority in our rebuilding project now underway. It will host diverse forms of performing arts and moving pictures: dance, music, theater, film, video, and everything in between and currently unimaginable.

This kind of change in the understanding of the nature of the museum must be the work of many people, and I am grateful to those at MoMA who have made it their goal. The group of publications to which this book belongs is the brainchild, inside the Museum, of Kathy Halbreich and, outside it, of the distinguished editor and writer David Velasco. Velasco also edited this volume, rigorously and sympathetically evoking Sarah Michelson's uncompromising vision through a constellation of diverse voices and approaches to writing about dance. As always, I am grateful to MoMA's Trustees, and in this case particularly to Wallis Annenberg. Through MoMA's Wallis Annenberg Fund for Innovation in Contemporary Art, the Annenberg Foundation has supported many performances at the Museum in recent years and has also provided major support for these books. Finally, I extend my profound gratitude to Sarah Michelson. The intelligence—formal, physical, and emotional—that characterizes her widely admired and intensely powerful works has both inspired and deeply informed this volume.

—Glenn D. Lowry, Director, The Museum of Modern Art

PREFACE

Modern dance loves a wrong place: for its practitioners, the stubborn physique of a church, a rooftop, a plaza, a street, or a gallery is a point of contact for kinesthetic innovation. So maybe it's no surprise that in the past five years The Museum of Modern Art, and in particular its Donald B. and Catherine C. Marron Atrium, has become a crucible for dance's experimentation with that long phenomenon called the modern. The Museum was designed primarily for the static arts, and the Atrium is an impossible place for dance, open and hard—yet few choreographers have put down a Marley floor to cushion its knee-cracking slate.

When the Museum opened its Yoshio Taniguchi–designed renovation in 2004, the critic Yve-Alain Bois called the Marron Atrium one of its "senseless features . . . a pure sumptuary expenditure, the sole practical function of which must be to host fund-raising events."[1] The Atrium—as an "ambulatory space" antagonistic to MoMA's most art-historically cogent objects, its "canvases by Monet, Brice Marden, and Agnes Martin"[2]—may indeed be senseless, but only in being, perhaps, too full of sense for pictures to compete. It is an empire of senses for the taking, perfect if you're the kind of artist who likes the conundrum of people on a floor. Unclaimed, unprotected, the Atrium is allowed to be "other" things to "other" people, a space for those who are adjacent to the visual art canon articulated in the Museum's galleries but for whom that canon never really worked.

"The wind of the canon" is how choreographer Sarah Michelson described her experience of the Atrium in 2012. "It was amazing to experience the wind of the canon blow me and Nicole to smithereens."[3] Her *Devotion Study #3* was part of a series called Some sweet day, in which choreographer Ralph Lemon invited seven artists to luff that modern wind. That canon and those dances inspired an entanglement of dance and art history at the Museum and the planning of a group of books, tendentiously titled "Modern Dance," as the child of that weird, rich coupling.

Why "Modern Dance," a phrase so obstinately tethered to the group of adventurous and ideologically diverse twentieth-century choreographers that included Isadora Duncan, Katherine Dunham, Martha Graham, and Merce Cunningham? There are two reasons. The first is simple: it refers to the books' institutional home at The Museum of Modern Art. Michelson, as well as Lemon (the artist with whom we began this series) and Boris Charmatz (whose book is being published simultaneously), have made significant works for MoMA, though the books are not tied to those works. The second is this: many of the

qualities that stick out in projects by Lemon, Michelson, Charmatz, and other choreographers working now seem to test and extend modern problems. These artists' questing after what dance *is*, their antagonism to the bourgeois (whatever *that* is), their interest in working with virtuosity/charisma, their no-yes-no to snaky spectacle, and their romance with the magic of singularity and self-mythology seem to argue with those "moderns" and "-isms" at play in the work of George Balanchine and Cunningham and Graham and Yvonne Rainer and scores of others who have made their mark upon the term.

When Rainer began to use the term "postmodern" in the early 1960s, historian Sally Banes tells us, it was in a chronological sense: the implication was that her peers in the Judson Dance Theater—Steve Paxton, Trisha Brown, Lucinda Childs, Deborah Hay, et al.—were "after" moderns like Graham or Cunningham.[4] Of course, as Banes also notes, the Judson dance makers may have been more "modernist" than their predecessors, with their stripped-down, ecumenical approach, but still the description stuck. Critics eventually read the term as an epistemological breach, which it was for some but not for others. Consider Paxton's recent response to Lemon, on the subject of artistic inheritance: "[Modern dance] is a collection of artists who didn't do what they had been taught. I think I am a Modern Dancer."[5]

Bad students: among the many definitions of modern dance, I like this one best. Typological contests are, of course, another feature of modernism and even a sign of its growing pains. Modernism may have matured since the twentieth century, but it continues to be vividly lived. For better or worse, the world is more modern, even if we have substituted modernity's contingency for its precarity. These artists who make amid modernity's triumph have as much (if not more) truck with the modern as those who made amid its earlier pitch and yaw. And consider: What more appropriate response could there be to modernism's "secularism" than Michelson's *Devotion*, to its tendency to collect and cauterize than Charmatz's Musée de la danse, to the vacuous thrill of white nonspace than Lemon's *Geography* lessons? These responses are not beyond the pale: they are a rendezvous with and within a canon. They are thinking the modern larger. They take this capacious category and make it wilder. Rather than flattening them in the mute "contemporary," why not open the modern's landscapes and allow those insubordinates and poor learners to terrorize its spirits? In any case, the choice isn't ours; it has already happened.

We conceived of these books as a way to offer our living dance iconoclasts the same resources afforded the plastic arts. We wanted comprehensive chronologies and sharp, analytic essays grounded in deep research: everything in one place, dedicated to the proleptic, curious other. And so the books present scholarship and expansive textual responses and an easily referenced list of works and bibliography. But, of course, they will not be identical. As questions arose, the shape of each book evolved. Why represent this way and not that? How

does and should a photograph relate to text? A text to a dance? One collaborator's voice to another's? The artists had problems to solve, as did the editors and writers tasked with putting it all to print. These books, to some extent, are the crystallized collision of artists and the people who think about them. Not crystallized as in set, but rather as a lattice that extends in many directions. Remember, crystals grow.

—David Velasco, Modern Dance series editor

NOTES

1. Yve-Alain Bois, "Embarrassing Riches," *Artforum*, February 2005, 137.

2. Ibid.

3. Sarah Michelson made this comment to the choreographer Ralph Lemon, who writes about it in his essay "B-Sides" in this volume.

4. Sally Banes, *Terpsichore in Sneakers: Post-Modern Dance* (Middletown, Conn.: Wesleyan University Press, 1987).

5. Steve Paxton, e-mail to Lemon, February 26, 2016. Paxton and Lemon shared their exchange with the author.

SHALL WE DANCE AT MOMA?
AN INTRODUCTION

Dance has a long, if discontinuous, history at The Museum of Modern Art. It begins in 1939, ten years after the Museum's founding, with a gift from patron Lincoln Kirstein of his personal archives of five thousand items relating to dance. With this collection from Kirstein (later a cofounder of the New York City Ballet) as its scholarly core, the Department of Dance and Theater Design was established in 1944, apparently the first such curatorial program in any museum; however, the department's exhibition efforts, including a display in 1945 of Barbara Morgan's photographs of modern dancers, were short-lived. The Museum, citing rising costs, disbanded the department in 1948 and transferred its archives to the MoMA Library. Despite the inclusive definition of modern art propounded by the Museum's founding director, Alfred H. Barr, Jr., it's likely that, without any precedent, it proved too difficult to integrate dance and theater history into the galleries.

Dance did not disappear entirely with the closing of the early department, although presentations were usually billed as ancillary or special events. For example, while modern dance appears to be absent from the Museum's programs in the 1950s, demonstrations by classical dancers from various countries accompanied international exhibitions such as 1955's *Textiles and Ornamental Arts in India*. Occasional films on dance were screened in the 1960s, but the discipline was largely overshadowed by the excitement surrounding multimedia productions, a new, more synthetic form shaped by artists involved with Happenings, experimental music, and film, as well as by theater directors and choreographers. Artists were invited to appear with some regularity in a variety of informal settings throughout the Museum, including the Abby Aldrich Rockefeller Sculpture Garden, where Jean Tinguely's 1960 assemblage *Homage to New York* was designed, with the assistance of Bell Labs scientist Billy Klüver, to gyrate until it fell to pieces in an act of accelerated self-destruction. Another sort of history was made that evening when Klüver met Robert Rauschenberg. This introduction led him to work with the artist and many of his colleagues associated with New York's Judson Dance Theater in the early 1960s as they radically transformed the definition of dance and foregrounded the natural alliance of artists across mediums. *Information*, MoMA's prescient 1970 exhibition of Conceptual art, made visible the new priority and interplay of disciplines by including the choreographer Yvonne Rainer, who had participated in the first Judson presentation, in 1962. But her sole contribution was a short and despondent catalogue statement

that began, "I am going thru hard times: In the shadow of real recent converging, passing, pressing, milling, swarming, pulsing, changing in this country, formalized choreographic gestures seem trivial," and ended with "Maybe fuck it."[1]

Reflecting a similar spirit of protest, two unanticipated performance interventions had disrupted the calm of the Museum one year earlier: Japanese artist Yayoi Kusama captured the front page of the New York *Daily News* in August 25, 1969, by directing a group of naked performers, who briefly occupied the Sculpture Garden for her piece *Grand Orgy to Awaken the Dead at MoMA*. In November, four members of the Guerilla Art Action Group, protesting alleged profits by MoMA patrons relating to the Vietnam War, entered the Museum's lobby and loudly began attacking each other, causing sacks of beef blood hidden under their clothes to spill. They then fell to the floor, as if the enemy had permanently silenced them.

In recognition of the aesthetic shifts that had become evident across disciplines, the four-part series Projects: Performance was programmed for the Sculpture Garden in August 1978. It focused on postmodern dance, music, and theater, including the work of playwright, filmmaker, and performance artist Stuart Sherman, who often displayed his silent choreography of objects on a card table furtively set up on the street. Choreographer Simone Forti began her long, if episodic, relationship with MoMA that summer. She would not appear again at the Museum until 2009, but, significantly, in 2015, after more than four years of conversations with the artist, MoMA acquired the rights to teach, perform, and reconstruct props for nine of her object-centered dances, likely the first such commitment made by a museum. This acquisition was championed by MoMA's six-year-old Department of Media and Performance Art, which had come into existence in 2009 when the title of the Department of Media Art, itself founded only three years earlier, was augmented to suggest its broader mandate. With this, dance became an ongoing curatorial prerogative at MoMA. I had arrived a year before in the role of associate director of the Museum, having been director of the Walker Art Center in Minneapolis, where a department for performing arts was officially established in 1970. However, for most of my sixteen years at the Walker, the majority of live events commissioned or organized by curators took place in partnership with other venues around the city, making it extremely difficult to elaborate in the museum the ways in which the histories of performing and visual arts were intertwined, if not mutually dependent. In 2005, with the opening of the Walker's expansion, designed by Herzog & de Meuron, a theater for 385 people with a stage the size normally found in a thousand-seat space became the primary place for the institution's dance, music, and theater presentations. It is near to the galleries and the screening rooms. But my hope for a continuous beat of open rehearsals, encouraging the daily visitor to loop effortlessly between exhibitions and performances, proved impractical.

Some of that proselytizing fervor, however, found an elastic container in MoMA's Donald B. and Catherine C. Marron Atrium. A big volume of space

that is a point both of transit and of gathering, it has been appropriately criticized as aggressively reverberant and impossible to adapt for proper theatrical lighting. Yet the Marron Atrium has been molded by artists into a strangely compelling place to experience dances, such as those created by choreographer Ralph Lemon or presented by him as part of the 2012 curatorial commission Some sweet day. Lemon recently wrote that the questions which shaped this effort were, "What is a good or a bad dance? What was the significance of the timing of the events, fifty years after the founding of Judson Dance Theater? What is the broader significance of the blues, black music, and race to contemporary dance? Which choreographers win in the tyranny of this anti-theatrical space? And, of course, which ones lose?"[2] This three-week series coincided with Hurricane Sandy, which essentially closed Lower Manhattan and cut it off from Brooklyn, making most of the performers' commutes arduous; however, due to the extraordinary commitment of artists, curators, and administrators, not one of the cross-generational presentations—dances choreographed by Jérôme Bel, Deborah Hay, Faustin Linyekula, Dean Moss (with artist Laylah Ali), Sarah Michelson, and Steve Paxton, along with a two-day performance by artist Kevin Beasley—was canceled. All played to large, appreciative audiences that seemed to have flocked to the Museum as much for a sense of collective well-being as for the art. The work they saw wasn't easy. When inviting the choreographers to participate, Lemon had directed each to explore ideas around black music; this prompt was never publicized, and the relationship between music and move-ment was more or less explicit, depending upon the artist. For instance, Paxton, believing the intellectual construct had little to do with his work, initially declined to participate, while Beasley attacked the problem with a vehemence that suggested his life depended upon finding answers. His thunderous sampling of slowed-down recordings of deceased rappers rumbled through the Museum at a decibel level so great that windows rattled and viewers described feeling the vibrations in their bodies. The Museum's usual canon was momentarily displaced, and blackness became the dominant, unavoidable aesthetic.

Histories of all sorts echo through the building when choreographers are in residence. In composing dances for presentation at MoMA, some have used the Museum's past and present practice as elements as decisive as the architecture. For example, in Michelson's *Devotion Study #3*, of 2012, choreographed for Lemon's series, she highlighted both the Museum's security staff, the major-ity of whom are people of color, and the pervasive impact of black artistic achievements on this nation's culture, making visible the dominant whiteness of MoMA's collection, architecture, and staff. Michelson cast two guards, Tyrese Kirkland and Gary Levy, who raced up the lobby stairs, protecting her petite, auburn-haired dancer as if she were a celebrity. The trio was greeted in the Atrium by the choreographer, who began to DJ a score composed of songs on the Tamla Motown label, soul music produced by Motown Records in Detroit

but sold primarily outside the United States. Between 1960 and 1969, seventy-nine of the one hundred top-selling records in the United States were produced by Motown,[3] precipitating a convergence of black and white popular culture just as unusual then as it is in most museums today.

When theatrical purity is knowingly sacrificed, other compelling characteristics assert themselves, and performers often discover an engagement with their audience they haven't experienced before. Paradoxically, the collision of the Atrium's spectacular scale and the flexibility of its usually unregulated and unorthodox seating plan often has resulted in increased intimacy. In 2011, Okwui Okpokwasili and Lemon, performing in the Atrium as part of the exhibition *On Line: Drawing through the Twentieth Century*, pushed themselves to near-exhaustion in a dance that had been previously presented only once before, in the modestly scaled sanctuary of New York's St. Mark's Church. Despite the cavernous size of the Atrium, Lemon was startled to feel the audience's breath on his body as it gathered around him. He described this exposure as "changing everything for me. An Armageddon."[4]

Performances in this nontheatrical setting often upset the authority of an institution best known for its singular permanent collection; they also suggest why the proscenium stage, with its restricted focus, no longer serves the immersive needs of some choreographers working today. For example, Boris Charmatz, choreographer and director of the Musée de la danse, in Rennes, France, explained the significance of seeing dance within the context of a museum: "We are at a time in history where a museum can modify BOTH preconceived ideas about museums AND one's ideas about dance. . . . In order to do so, we must first of all forget the image of a traditional museum, because our space is firstly a mental one."[5] Musée de la danse: Three Collective Gestures, a three-week, tripartite residency at MoMA in 2013, was Charmatz's attempt to demonstrate his institutional aspirations by juxtaposing the enduring qualities of objects in the Museum's collection with the ephemeral nature of dance and dancers' bodies. For *20 Dancers for the XX Century*, one component of this program, twenty dancers of all ages and several cultural backgrounds colonized the Museum's public spaces and galleries, where they greeted surprised visitors and, after a short explanation, began to perform their adaptations of solo works created throughout the twentieth century. For example, in the gallery housing Richard Serra's massive sculpture *Delineator*, of 1974–75, a senior member of the Trisha Brown Dance Company invited the public to join her in replicating a sequence of Brown's most characteristic movements. In another gallery, actor Jim Fletcher reenacted Vito Acconci's 1970 performance *Trademarks* while sprawled naked next to the painting *Self-Portrait with Palette*, of 1924, by Lovis Corinth, an artist deemed degenerate by the Nazis. Together the twenty differently trained performers created a living archive of both well-known and forgotten compositions, surrounded by works from MoMA's collection.

Consequently, it was possible in a single visit to experience many art histories. By placing them in such close proximity, Charmatz and his team created, at least for a few days, a temporary institution that, in its inclusivity and exuberance, redeemed the equality of the thought, the thing, and the movement in the museum setting.

While there is a core group of aficionados who attend every performance at MoMA, the majority of visitors come to dance by chance. Once, while I was waiting on a balcony for Anne Teresa De Keersmaeker to begin a section of her 1982 dance work *Fase: Four Movements to the Music of Steve Reich*, part of *On Line*, a visitor squeezed in beside me and asked, "What's going on?" I paused in my conversation with an actor from the Wooster Group (a staple of New York downtown theater), who had come especially to see this performance, but the action below began before I could answer. All three of us were silent and still for sixteen minutes, while De Keersmaeker's slow, circular, and repetitive movements etched a drawing in the sand spread on the Atrium floor; as the performance ended, the visitor said, "I never knew such a thing existed, and I am thrilled to have seen it." Certainly, some impatiently turned away, but for this visitor the unanticipated encounter had a special persuasive, focused power.

The opportunity to connect a dance to a work of art in the collection amplifies a historical moment in ways that usually are truer to the artistic process and period than viewing the disciplines separately. Annette Michelson wrote in her influential *Artforum* essay in 1974 that "the New Dance . . . set out in much the same manner as the new sculpture of the 1960s to contest, point for point, esthetic conventions which had acquired an ontological status, by rehabilitating, installing within the dance fabric, the task, the movement whose quality is determined by its specifically operational character."[6] For example, when given the assignment by his teacher Robert Ellis Dunn to make a one-minute dance, Paxton "simply" sat on a bench and ate a sandwich. In 2012, Paxton—a choreographer who, Rainer jokes, invented walking—restaged his *Satisfyin Lover*, of 1967, with a customary mix of both trained and amateur performers, each of whom ambled undramatically across the Atrium. This framing of the repetition of unspectacular, pedestrian motion reminded everyone—performer and viewer alike—what every child learns and adults necessarily forget in order to move forward: these quotidian actions are complicated and require great physical erudition. Despite the affectless quality of the movement, one couldn't help but notice the infinite individual quirks that gave shape to the group. There was an obvious continuity of concerns between Paxton's desires and the cool, non-illusionistic sculptures of Minimalists such as Robert Morris, who also made performances and occasionally danced with Rainer; however, there was an even greater resonance with the irreverent and humorous ways Rauschenberg, in abjuring the heroics of Abstract Expressionism, minimized the distinctions between the artist and the audience, treasure and trash. In fact, there are myriad

connections between Rauschenberg and Paxton, who danced for Merce Cunningham's company at the same time the artist served as its stage manager. Besides sharing a loft, they participated in many of the same productions at Judson Memorial Church. And, despite his sensational success—at the Venice Biennale in 1964, Rauschenberg was the first American to win the grand prize in painting—he understood what could be learned from his less well-known friend, remarking once how much he "admired and envied the situation of the Cunningham dancers . . . because for them there never was a definitive way of doing things."[7]

It isn't difficult to imagine, then, how aware Paxton must have been in October 2012 of occupying for the first time the same institution where his colleague's paintings had hung for many years. But, in mining further the history of these two experimental giants, it appears that neither artist nor choreographer was fully accepted by MoMA until recently. For example, two of Rauschenberg's greatest paintings—*Rebus*, 1955, and *Canyon*, 1959—were passed up for purchase by Barr when he was director; happily, both were acquired by the Museum over the past decade.[8] Only by layering the narratives of these two innovators is it possible to truly chronicle their individual trajectories, the cross-disciplinary thinking that has shaped so much of the art made in New York, and MoMA's own curatorial proclivities over the last sixty years. It's a history, made of zigzags and circuits, that has yet to be fully documented. It certainly sets in motion an alternative to the progressive linearity of the modern canon as it has come to be inscribed by this museum.

MoMA is currently in the midst of an expansion. One of the new spaces, tentatively identified as "The Studio," will be fully outfitted for all sorts of performances. Perhaps most importantly, this intimate but technologically and acoustically sophisticated space will be located in the middle of a sequence of galleries containing contemporary painting, sculpture, works on paper, photography, design, architecture, video, and film. The history of modern dance, music, and theater will be intimately and routinely connected to that of other art forms. Curators will rehearse a more complex drama of objects, moving pictures, and live performers that together portray the wildness of the questions that shaped the twentieth century as well as those that unsettle the status quo today. While still using the Atrium and other spaces when appropriate, performers at the Museum will finally take their bows on a stage that properly embodies the capacious revolutions of modernism. And, in the future, it may be possible to register a continuous history of dance at MoMA, with Kirstein's archives once again providing an invaluable public resource. MoMA's series of Modern Dance books on practicing choreographers, to which this volume belongs, is just a beginning.

—Kathy Halbreich, Associate Director and Laurenz Foundation Curator,
The Museum of Modern Art

NOTES

I am extremely grateful to past and present curators at MoMA who believed in a museum of many moving parts and to director Glenn D. Lowry for realizing it. We all would be far more reticent to reconsider the Museum's own history were it not for the daring of the artists whom we learn from every day.

1. Yvonne Rainer, artist statement in *Information*, ed. Kynaston L. McShine (New York: The Museum of Modern Art, 1970), 116.

2. Ralph Lemon, "I'd Rather Talk About the Post-Part," *Triple Canopy*, August 4, 2015, http://canopycanopycanopy.com/series/passage-of-a-rumor/contents/id-rather-talk-about-the-post-part.

3. Charlie Gillett, *The Sound of the City: The Rise of Rock and Roll* (London: Sphere Books, 1971), 247.

4. Lemon, e-mail to the author, June 30, 2015.

5. Boris Charmatz, "Manifesto for Dancing Museum" (Rennes, France: Centre chorégraphique national de Rennes et de Bretagne, 2009), www.borischarmatz.org/sites/borischarmatz.org/files/images/manifesto_dancing_museum100401.pdf. For the French version, see "Manifeste pour musée de la danse," www.borischarmatz.org/sites/borischarmatz.org/files/images/manifeste_musee_de_la_danse100401.pdf.

6. Annette Michelson, "Yvonne Rainer, Part One: The Dancer and the Dance," *Artforum*, January 1974, 58.

7. Calvin Tomkins, "Everything in Sight: Robert Rauschenberg's New Life," *New Yorker*, May 23, 2005.

8. The first painting by Robert Rauschenberg to enter MoMA's collection was *First Landing Jump*, of 1961. It was acquired eleven years after it was made, following the purchase of groups of prints and drawings in the early 1960s.

I MET SARAH MICHELSON...

Greg Zuccolo

I met Sarah Michelson in a dive bar in Williamsburg. She was on her knees screaming, "I love you." She was off her face on martinis. "I LOVE YOU!" over and over again in that half-Manc/half-American accent that can be so off-putting to some. Music to my ears.

I met Sarah Michelson in front of a health food store in SoHo. She hadn't applied her makeup very well. She looked like an aging raver-clown. Bad blending from chin to neck, you know the sort. Music to my ears.

I met Sarah Michelson when she and Miguel Gutierrez were drunk . . . and they spotted me at Florent. They both whispered "He's a god" in my general direction. Music to my ears.

I met Sarah Michelson when she finally had the balls to ask me to replace Miguel in *Group Experience* in 2001. He and Parker Lutz were unable to fulfill their contracts because John Jasperse, of all people, needed their efforts elsewhere. Music to my ears.

And thus began a long and delightful ride—a dressage, if you will—that she and I and many others took. Full stop.

Let me get the delightful bit out of the way first.

Sarah is a great spy. Even better, she is a great teacher of spies. She's like MI6 or 8 or whatever. Anyway, she gets her feelers out. She has her finger on the pulse or the lack thereof, as the case may be. She knew I was an accomplished dancer and capable of some amount of panache, virtuosity, élan, baloney, dance-crushingness. She put me up. She asked me to dance all the way to the end of the way I could think of to dance, and no collaborator/choreographer I'd worked with had ever asked that much. Never from my dancing. And my dancing is most precious to me. She spied that.

But it comes with a price.

I was spotted as a talent in a senior high school play. A production of *The Importance of Being Earnest*. I played Algernon. There was a proper drama department at Centennial Senior High in Coquitlam, British Columbia. They had dance classes and everything. Real jazz. I stood out. I couldn't keep track of the steps, but I never missed a beat. (This is a side note for all dance students.)

I was told to go off and audition for the Royal Winnipeg Ballet. I was accepted. I was despised, and the rest will be the rest of this story.

I danced with the Opéra Royale de Wallonie, Tere O'Connor, Stanley Love, Baryshnikov—like that. Anyway!

The first proper production I appeared in with Sarah was *Grivdon at the Grivdon Concrete* in 2002. She and I went out at some point during the process and got drunk and compared our Scottish accents and the way the title would sound with a Scottish accent. Try it. Mine was better than hers. She was surprised.

Next were *Shadowmann: Part 1* and *Part 2*, the following year. I grew a beard for the first part and shaved everything save the mustache for the second. Sounds like a Leonard Cohen poem. We toured the world and presented that impossible project in some of the most impossible places. I could go on and describe some of those places and the exhausting work, but I think a personal story says it best. At one point in *Shadowmann: Part 1*—I think we were at the Arsenale in Venice—as we were approaching the end I felt a fart coming on, but I was so exhausted that I was worried something else would come out, and, sure enough, it did: one tomato seed in my CBGB panties from some shit shop on St. Mark's Place.

Then, in 2005, came *Daylight*. I believe Parker was the first dancer ever to say, "I HATE DANCING EVERY DAY!" This perfectly verbalizes the existential risk one takes when becoming a dancer. (Speak the preceding and the present sentences in a Scottish accent. It makes everything better.) In rehearsal I had to teach at least seventy-eight separate moves to Mike Iveson while Parker and Sarah sat in a corner whispering to each other, legs up the wall, blithely conjuring tacit moves. As in, they didn't tell me and Mike what they were. In the meantime, Mike and I set up the elaborate situation Sarah had mapped out with the portable ballet barres at City Center: real grunt work (see glossary). And then *die Schlampen* came at us with the "new way" to do the phrases.

CUNTS!

At one point I said to Mike, while we were schlepping barres around, "They're like each other's Rasputin. Am I right?"

Then there was *DOGS*, in 2006, and *Dover Beach*, two years later.

Sarah and I got tired of dealing with each other. The fights got closer together. I didn't know where I was supposed to be half the time. My part in *DOGS*, in the second bit, is Parker's part from the first act. I fucked with it a bit and Sarah nodded (barely) at the changes, but she didn't say one word to me during that process. She can contest that, but, once again: see glossary.

For *Dover Beach*, every male dancer Sarah auditioned said no. When she finally asked me, I broke down in tears. I thought she was bored with me, but

it turned out she was just worried that I was a cranky old drunk who'd scare children. Music to my ears, and: see glossary.

Or "gloss-over-each."

There is nothing to lose but love. There is nothing to lose here. And that makes us all clingy and shitty, and fuck . . . I love Sarah. She takes me places I've never been.

IN REVERENCE TO THE AMERICAN SPIRIT: EARLY WORKS BY SARAH MICHELSON

Gia Kourlas

The morning after I saw *Devotion*, Sarah Michelson's 2011 homage to a passing generation of choreographers, I sent her a quote from George Balanchine:

> Superficial Europeans are accustomed to say that American artists have no "soul." This is wrong. America has its own spirit—cold, crystalline, luminous, hard as light. . . . Good American dancers can express clean emotion in a manner that might almost be termed angelic. By angelic I mean the quality supposedly enjoyed by the angels, who, when they relate a tragic situation, do not themselves suffer.[1]

Her dance, for me, was an illustration of Balanchine's sentiment, of a shared value system. (She included the passage as the epigraph of her next work, *Devotion Study #1—The American Dancer*, for which she was awarded the prestigious Bucksbaum Award at the 2012 Whitney Biennial.) Clearly there is "clean emotion" in a Michelson dancer; their angelic devotion is pure and extreme—unfettered by outside forces and melodrama. Yes, there is the startling use of space, of costumes, of lighting, but all are in service of dance, its formal concerns, and its ancestors.

But long before Michelson became defined by her devotion to this world and its word—choreography—she made a dance, a successful one, as it happens. It was 1989 and Michelson was living in San Francisco. The work, performed at the New Performance Gallery, a space run by the dancer and choreographer Margaret Jenkins, was called *Cindy Camille Sheila and Shirley*. As in many of her earliest dances, the cast was all women. "It was very heartfelt," Michelson has said. "Guttural, knee-jerk, naïve."[2]

That work, part of a shared evening, was born, in a way, out of revenge. In San Francisco, Michelson regularly attended Jenkins's diabolically fast Cunningham class, where she encountered Sri Louise, now a revered yoga teacher. (They later moved to New York together.) She has described the day Sri Louise arrived in class: "Long blond hair to the ass, blue eyes. Total virtuoso. Stands in my spot. I just move over slightly. I'm short-haired and fat, and then she's really incredible, and I hate her."

Michelson can't remember how much time passed—a few days? a week?—between meeting Sri Louise and her audition for a local choreographer who was looking for dancers. Michelson wasn't chosen for the project; she was enraged. The next day, after class, she announced with typical fire that she was going to make her own. "Who wants to be in my dance?" she recalls asking. "And I hear, '*I* wanna be in your dance.'"

The voice, to her dismay, belonged to Sri Louise, perhaps the first of many charismatic dancers drawn to Michelson's universe. The dance was widely admired, though a mentor advised her that if she wanted to have a career, "basically, not to make lesbian works."

Was it a good dance, whatever that means? Michelson is sure of one thing: at that point, she didn't feel she was a choreographer. She's never been able to completely articulate why she wasn't ready to embrace the title. I wonder if it had something to do with how the dance was born—out of reaction and not a question. But there's another possibility: Michelson is wary of anything that comes too easily. She may have deemed that first effort too clever, too obvious. It's related, perhaps, to the way she later regarded her two-part *Shadowmann*, of 2003, as a test of intelligence. Whenever presenters expressed too much reverence for the first part over its second—its quiet, strange, intimate distillation—she would know that they were drawn to spectacle over substance.

Most choreographers figure out what they're good at and continue that way, occasionally slipping off the edge but rarely making a sharp turn. Michelson keeps turning. When a dance seems like a potential crowd-pleaser, she starts over; when her dancers begin to own the material—controlling the performance in a way that betrays its vivid, tremulous foundation—she makes her choreography so impossible that the only way to survive it is through a methodical, precise execution. So-called mastery dulls her blade.

Survival and urgency form the core of Michelson's work, in which she creates spaces of rigid order, almost manically controlled. "Almost" is key; her dances possess air and fantasy, which always, on some level, relate to her early life. The product of a complicated class system—Michelson grew up poor in Manchester, England, with an unaffectionate mother and a set of dear friends with whom she lived as a child—she gets across, in her early and recent works especially, some sense of the pull between bleakness and beauty, or rather the rare beauty that emerges when you stare long enough at misery.

Following *Cindy Camille Sheila and Shirley*, Michelson returned to New York, in 1991, to study at the Merce Cunnningham School. During this period she presented at least two more works: *Where God Is Now*, at the Merce Cunningham Dance Studio in 1993, and *Glory (Glory Glory Glory)*, in 1993 at Danspace Project, featuring Chris Bergman and herself; the latter was, despite the warning, a lesbian duet. "I had a shaved head, and I wore a long, black, 1970s turtleneck slightly A-line dress that had sequined sleeves, but it was super weird and tight, and then

boots," Michelson has said. "[Bergman] had long frilly hair then, and she wore a really ruffled white dress and boots, and it was faux-sexual. Passionate, stamping around and a lot of hard dancing; it felt very cutting edge." Jack Anderson, in the *New York Times*, wrote that it "was vague in dramatic motivation, yet vivid nonetheless because of the energy of its dancers."[3]

After *Glory*, that restless energy took Michelson to Spain, where her plan was to study flamenco. Soon she realized that for a non-Spanish woman "it was a loser's game," and she moved to London, where she studied dance and experienced a life-changing moment during a class taught by Jeremy Nelson at Greenwich Dance Agency. He told her that she should be in New York City, that he had a bed if she needed one, and that he would be teaching at Movement Research, an openhearted laboratory for downtown dancers in New York, the following March.

Michelson took his advice. She walked into the Movement Research office, where she met Julie Atlas Muz, a performer with whom she would create *Blister Me* for New York's Dixon Place, in 2000, a duet that involved nudity, urination on recycling bags, and that degree of commitment many are familiar with by now. (Muz, a charismatic member of the downtown scene in the 1990s, went on to become a well-regarded burlesque artist.) Michelson was broke and couldn't afford to take a dance class; Muz told her that she could be an intern.

In the fall of 1995, I became dance editor for *Time Out New York*, a weekly arts-and-entertainment magazine. One night Michelson called me to demand that I model the listings after the London version of *Time Out*—meaning that they should be comprehensive and cover more than conventional performances. Had she even opened the magazine? That's exactly what I had been doing, but I listened to her rant without cutting her off, because it wasn't what she was saying that interested me but how she was saying it. This crazy person on the other end of the line was as beautifully and as stupidly devoted to dance as I was.

Even before that phone call, I had seen her perform. There was something indelible about the way her presence could shift the energy in a room, whether in the audience—she saw everything—or on a stage. In order to better grasp the insular downtown dance scene, I used Michelson as a guide, making a point to attend any performance she was in. If she was in a work, there had to be some merit to it, right? Not the first time my thinking has been flawed, but I learned from the mistakes, too; what was always palpable was the thrust of her power, the force that was coming from her obvious intelligence. Was she a choreographer? It didn't even occur to me to think in those terms. I was learning about other choreographers by watching her—figuring out when she was properly used and when she wasn't, wondering why others didn't use her at all and thinking them fools because of it.

I gleaned much about how choreographers underuse dancers. How do those dancers react? Michelson usually—at least back then—chose to retreat inside herself, and the quieter she became the less anyone else onstage had a chance. What she was dancing often didn't matter; her penetrating focus, her ability to control

a stage, especially in inferior work, felt pointed and masterful. It was never about showing off; she could be rash or subdued, but, again, there was urgency without desperation, a dead-on seriousness despite the humor. Over time, I realized that this was not a learned state but an inherent one, and it's a quality I can now detect when it is present in other dancers, no matter the discipline.

As a dancer, Michelson performed with just about everyone in New York: DD Dorvillier, Jennifer Monson, ChameckiLerner, Jon Kinzel, Paige Martin, Yoshiko Chuma, Nami Yamamoto, Cydney Wilkes, and LAVA. (For the last, an all-female company of downtown acrobats led by Sarah East Johnson, she even trained at a circus school.) Her relationship with ChameckiLerner, a company led by Rosane Chamecki and Andrea Lerner, was meaningful—there she danced with the chore-ographer Maria Hassabi—but she has credited Monson and Dorvillier, who lived and worked in a former matzoh factory in Williamsburg, Brooklyn, from 1991 to 2002, with being the most important and influential artists in her life: "It was really understanding that the interrogation is where the value is. They taught me that."

In 2001 Michelson showed her *Prelude to Fawn* at Brooklyn Arts Exchange and the complete *I'm in Fawn* a month later at the Kitchen, in Manhattan. A transformative piece that preceded her award-winning *Group Experience* later that year—looking back, it feels like its prologue—*I'm in Fawn* was audacious, raw, and startlingly confident. We could hear Michelson's forthright choreo-graphic voice, with odd injections of text (chants of "peaches for skin, peaches for skin") and an elastic understanding of space and everyday materials, like cardboard and rope, which would also find their way into *Group Experience*. ("Fawn" referred to the color of pantyhose the dancers wore onstage.) *I'm in Fawn* ushered in Michelson's second choreographic period. The first had begun with the early all-female work. The second, ending with *Daylight, Daylight (for Minneapolis)*, and *Daylight (for Seattle)* in 2005, focused on the relationship between Michelson and her main dancers of that period: Mike Iveson, Parker Lutz, and Greg Zuccolo.

Michelson's choreography is embedded with generative references, both to her own works and to those of others. The pivot step from her *Grivdon at the Grivdon Concrete*, of 2002, is what the young girls executed in *Shadowmann: Part 1* the following year. Non Griffiths's sneaker solo in 2011's *Devotion* is set to Philip Glass's score for Tharp's *In the Upper Room*, of 1986 (which I first took Michelson to see at American Ballet Theatre), evoking Tharp's ballet and its Norma Kamali costumes, but it had more of a connection to Lucinda Childs's *Dance*, of 1979, also set to music by Glass. The triplets from *Devotion* were the basis for 2012's *Devotion Study #1*. The tendu–hip roll in *Daylight* was featured prominently in *Love Is Everything*, a work created for the Lyon Opera Ballet, which showcased Claude Wampler's portrait paintings of the members of the artistic staff there. Both works were performed in 2005. Portraits by Wampler also appeared in the Walker Art Center's production *Daylight (for Minneapolis)*,

later that year. Yet, while the material of one work has driven the next, beyond a mirroring of movement or costuming, the strongest link has been the dancers.

It was after a performance of *I'm in Fawn* that Lutz, whom Michelson had long admired in the John Jasperse Company, approached her. All of Michelson's dances are personal experiences made public, but the bond among Michelson, Iveson, Lutz, and Zuccolo—whose first performance all together was *Grivdon at the Grivdon Concrete* in 2002 and whose last was the quartet in *Daylight (for Minneapolis)*—made it seem as though access, however veiled, was being given to a private world. Their bond was indisputable, and their presence defined the works more than the choreography did.

One of the main features of *Group Experience*, performed in 2001 in the downstairs theater at New York's P.S. 122 on a bed of plush, white carpet, was Michelson's merging of trained and untrained dancers: Glen Rumsey and Cheryl Therrien of the Merce Cunningham Dance Company and Lutz and Miguel Gutierrez of the John Jasperse Company, alongside the less-schooled Iveson, Tony Stinkmetal, and Tanya Uhlmann; Uhlmann had some training and was a respected yoga teacher, but she did not have a conservatory background. (When Gutierrez and Lutz went on tour with Jasperse, Zuccolo, who trained at the school of the Royal Winnipeg Ballet and danced with Tere O'Connor, and Adrienne Truscott, a dancer with experience in cabaret and the circus, replaced them.) Along with holding an extended relevé as a group—wobbles were meant to be seen—they referenced dance movements by Paul Taylor and Cunningham, all of which, at the time, seemed like uncharted territory. Highlighting technique or the lack of it was not on the minds of downtown artists at the time, and Taylor was, as he remains, an unlikely choreographer for an artist with a more daring aesthetic to align herself with; while his dances sometimes take risks, his movement vocabulary is traditional modern dance. The point, however, was to show a group of dancers—no matter their skill level—sharing the same stage and breathing the same air.

"*Group Experience* would probably fall under the category of the first novel," Michelson has said. "It's not the best work, but it has everything in it, somehow. Then later you have to work harder. Not that we didn't work hard for that, but it's like, what is your work going to be? You're waiting your whole life to burst this thing out and there it is, and then after that you have to figure out: What's my work?" She came closer to answering that in *Grivdon at the Grivdon Concrete*. Having just completed 2002's *The Experts* for the now-defunct White Oak Dance Project, a work commissioned by Mikhail Baryshnikov after he saw *Group Experience*, she took what she had learned in that project about working on the proscenium stage and applied it to *Grivdon*, performed in the Kitchen's gallery space. Before, she has said, she only understood a single viewpoint; now she could grasp perspective, depth, and breadth.

In *The Experts*, the eight dancers—including Jennifer Howard, whom Michelson would use in subsequent works—performed on a floor of bubble wrap

that snapped with every step. It was a contained world with an obvious title; Baryshnikov was its leader. In a huddle formation, the dancers undulated their hips until Baryshnikov broke free. He twitched spastically with his wrists bound, then later stood still, uttering an occasional moan as Emily Coates ran around the stage in circles. Every so often she placed her gloved hand on his shoulder and said, "Yes." *The Experts* was both odd and fresh, partly because of the caliber of the dancers in contrast to the material; while Baryshnikov moaned and Coates ran, the others gathered on a mound erected on the stage—a hillock—and quietly rocked back and forth or stumbled off it. Michelson's experiment was aimed at extracting the classicism from the dancers. Habits are hard to break; Howard called it a shedding of the skin: "I had to let go of ideas that I had about myself and dance. I had to trust her and myself and try something new and it worked out."[4]

The Experts was about a choreographer searching for her way; in *Grivdon*, Michelson found it. Stinkmetal, suspended on a board, was raised into the air for the work's duration, while Michelson and Lutz, wearing matching white dresses emblazoned with Dolce & Gabbana logos, moved in tandem—a sign of the doppelgänger motif to come in her work. The dance began to the left of the audience, with Michelson, Lutz, Iveson, Zuccolo, and Uhlmann rubbing their backs against a wall; suddenly the gyrations stopped and they each stood in profile with an arm, elbow bent, held out to the side. In that moment the scene shifted from something vaguely pornographic to antiquity. A pivot step, given greater emphasis by the dancers' footwear—black dance sneakers with a reinforced toe, the sort you see in jazz class—lent the movement a dodgy grandeur. Here, repetition granted the stage a pulse: dispersing and gathering in sudden fits and starts, the dancers continued their versions of the pivot step, raising their arms in diamond shapes. Iveson, with his belly peeking out between pants and shirt, looked slightly ridiculous, yet, as always, his assiduity was aristocratic. The dancers' bond was significant: Zuccolo, left alone for a moment after the others ran into a corner, suddenly sprang into the air and joined them, like a wolf returning to the pack.

As the Depeche Mode song "Goodnight Lovers" played, *Grivdon* became a different sort of "group experience": even more insular than that earlier work, it had something to say about the anti-mannerism of mannerism—a carefully cultivated performance quality in which the dancers, who knew, of course, that they were being watched, never acknowledged the audience's gaze. In *Shadowmann* and *Daylight* this approach would be pushed further, but in *Grivdon* there was a winning rawness as the dancers moved in pairs and huddles, kicking and pivoting like pieces of machinery in a factory. The steps contrasted with the sentimentality of the lyrics: "When you're born a lover, you're born to suffer." In *Grivdon*, Michelson's "soul sisters" and "soul brothers"—as described in the song—were connected through a system of movements as finely arranged and tuned (or purposely out of tune) as instruments in an orchestra.

After the acclaim of 2003's two-part *Shadowmann*, in which the dance was performed as spectacle at one venue (the Kitchen) and then deconstructed and stripped down for another (P.S. 122), Michelson created *Love Is Everything* for the Lyon Opera Ballet and began to choreograph the final dance to feature Iveson, Lutz, Zuccolo, and herself. Commissioned by P.S. 122 and the Walker Art Center, the production was a response to the Minneapolis institution's new building, designed by the Swiss firm Herzog & de Meuron. It was performed as *Daylight*, at P.S. 122, and, expanded, as *Daylight (for Minneapolis)*, which extended the work into the highest reaches of the Walker's new theater and surrounding indoor and outdoor spaces.

Daylight (for Minneapolis) shared a signature step with *Love Is Everything*: with their hands resting on their hips, the dancers stretched one foot to the front and then to the back as their hips undulated and their elbows followed suit. Wearing tan leotards adorned with white stencils to match the design of the Walker's theater, the dancers—mainly young girls and many with their hair dyed red (an allusion to the dancer Peggy Grelat-Dupont, who had performed the same steps in *Love Is Everything*)—appeared in gallery spaces, on window ledges, in hallways, on the roof, and in the patches of green grass that surrounded the building.

The architecture played with hiding and revealing; Michelson did the same on a smaller scale. The quartet was performed on the main stage, but behind it—only visible to those who sat above—was another performance area that featured Jennifer Howard and the young leotard-clad dancers performing the hip-undulation phrase. In its transference from body to body in various states of execution, by trained and untrained dancers, the phrase showed decay as well as a powerful, pointed precision. It may be seen as an expansion of the wobbly relevé moment in *Group Experience*.

Love Is Everything and *Daylight (for Minneapolis)*, two of Michelson's most important and interconnected works, are linked most significantly not in how they looked—though they featured similar steps and Wampler's majestic portraits—but because they signaled the start of Michelson's independence as a choreographer. As she began to shift away from her tight-knit group of dancer-collaborators, her choreography changed. In *Love Is Everything,* Michelson worked with highly trained dancers—sending them galloping around the stage like horses—and highlighted the lithe Grelat-Dupont as the star. It ended with the performance of an original pop song, "Money Is Better Than Love," by Michelson, Iveson, Lutz, and Zuccolo in the back of the theater. In *Daylight (for Minneapolis)*, the dancers moved to the roof; the audience watched from the street. Yet in contrast to such showier distractions, Michelson's movement—its execution—had begun to grow more stringent, acquiring a determined breadth with the addition of the bodies of unformed young girls, just as the ballet-trained Howard hinted at the adult dancers Michelson would be drawn to in the future: it was technical, yes, but with a natural, open expression.

In *DOGS*, commissioned by the Brooklyn Academy of Music in 2006, Michelson continued to steer away from the simplistic unison movement of *Group*

Experience and *Shadowmann*, developing a more sophisticated palette. The work's centerpiece was a starkly luminous solo for Lutz who, in off-white, creamily spun across the stage of the BAM Harvey Theater like a swan gliding in a lake. But Michelson's choreographic development was most apparent in an intricate mirrored duet performed by Howard and herself (both in black), while their ghostly doppelgängers, Laura Weston (blond, like Howard) and Alice Downing (brunette, like Michelson)—both in their early twenties—swirled in fog like a pair of lost Wilis rising from their graves. The effect of this double unison, particularly the haughty pairing of Michelson and Howard, was far more labyrinthine and specific than anything she had created to that point. Before, more straightforward unison vocabulary had provided a way for Michelson to see the overall structure of a dance. Now there was real intricacy: a microscopic investigation of finite balance and placement, starting with the foot in relevé. *DOGS* was a bridge: it led the way to 2008's *Dover Beach* and beyond, marking the beginning of a new phase in Michelson's choreography. It's no coincidence that it also was her final appearance as a dancer in her own work. When she pulled herself out, she could return to what she had started in *Daylight (for Minneapolis)*: setting movement, more complex than the pivot step of *Grivdon* and *Shadowmann*, on unformed bodies.

Dover Beach, performed at Chapter Arts Centre in Cardiff, Wales (preceding the 2009 performance at the Kitchen by eight months), was the next turning point for Michelson. The period of work originating with *Dover Beach* and continuing through to the Devotion series, of 2011–15, signaled her independence. As much as she had relied on Iveson, Lutz, and Zuccolo, she had also been bound by them; working on *Dover Beach* gave her autonomy. Before, she had seemed fearless, but now she really was. She had always had a choreographic voice, but now she trusted it.

The new work coincided with the illness of her grandmother, in Manchester; Michelson accepted residencies from Chapter Arts Centre over two and a half years to be closer to her. What occurred in Cardiff was especially transformative and time-consuming. The starting point was Michelson's observation of a children's ballet class, where she encountered two young students who would become her performers: Non Griffiths, Gwenllian Davies, and Latysha Antonio.[5]

With distance from New York, Michelson found herself investigating dance movements and performance in a way that felt radical: without relying on repetition, without trying to build importance on any particular one, she trained her dancers to execute each movement with separate intention. She called this approach "single value." Instead of creating movements that a dancer would make less awkward through repeated practice—making those seemingly invisible adjustments that can smooth out choreography in order to make a dancer look or feel her best—Michelson wanted no transitions, so that each movement would be its own entity. Because of this, there are echoes of Eadweard Muybridge's photographic motion studies in the performance quality of the work.

If *Group Experience* was the first novel and the Devotion series the masterpiece, *Dover Beach* was the latter's prologue: a study in how to create detailed movement that could exist free of interpretation—not tarnished, in other words, by a dancer's musicality or history. Largely a transcendent duet for Griffiths and Laura Weston, in which the pair progressed from one position to the next—variations on a fourth-position plié with contractions, a raised knee into a sous-sous turn with an elbow bent in front of the head—it is an illustration of non-accumulative value. The duo, performing in Cardiff and New York, possessed such tenacious commitment that you felt they wouldn't stop even if an earthquake hit.

Michelson's subsequent choreography has been increasingly austere and uncompromisingly tough, but it is also characterized by a gossamer fluidity that stems from the deep energetic exchange she experiences with her dancers. That approach has become more complicated in recent work, but it is not completely new; for Michelson, a dance has never been made just from steps alone. In a post-performance discussion about *Grivdon*, in 2002, she spoke about how she worked "specifically with how you create a feeling for yourself [as a dancer] by having a certain outlook." At present, she has sophisticated systems in place that seem to deal as much with a dancer's mind as with his or her body; an emptying out must occur for each to embody the movement in a way that doesn't depend on emotions.

While any of Michelson's works can be dissected to reveal reference, movement invention, transformation of space, and musicality, what is harder to quantify but abundantly evident is their moral base. There are always questions at stake. "I do think that I live in not knowing," Michelson has said. "Deeply not knowing, and that I try to really build the work and present it in a place of not knowing. Maybe I'm not making dance. Maybe I'm just making a problem." As the problems mount, perhaps her practice is about unmasking the dancer: showing, from the inside out, the place where vulnerability and resilience meet. It's the quest for that clean American spirit: cold, crystalline, luminous, and hard as light. She peels back the surface—of a dancer, of a dance—until it's raw and just icy enough to burn.

NOTES

1. George Balanchine, quoted in Jennifer Homans, *Apollo's Angels: A History of Ballet* (New York: Random House), 470. Homans cites the *New York Herald Tribune*, April 9, 1944 (reprinted from *Dance News*).

2. This and all unattributed quotations below come from interviews with Sarah Michelson by the author, July 24 and August 26, 2015.

3. Jack Anderson, "Repression, Romanticism and Rebirth," *New York Times*, November 25, 1993.

4. Jennifer Howard, quoted in Gia Kourlas, "Howard's End," *Time Out New York*, October 12, 2006.

5. "It had something to do with the fascinating thing of watching the archetypal movements of ballet and these children who didn't yet know what they were," Michelson said in a 2009 interview. "The young ones—understanding that they're learning something historical, that has existed for a long time in the most basic way. They know that there's a perfect version of this form, and they're doing these movements to a cassette recorder." Kourlas, "Sarah Michelson: The Award-Winning Choreographer Presents *Dover Beach* at the Kitchen," *Time Out New York*, June 2, 2009.

DESPITE THE DARKLING PLAIN: SARAH MICHELSON'S DOVER BEACH

Debra Singer

Being the right thing in the wrong space and the wrong thing in the right space can often be the most interesting position to occupy, or so goes the Warholian adage.[1] This aphorism certainly applies to Sarah Michelson's *Dover Beach*, which was presented in a small, light-filled classroom at Chapter Arts Centre in Cardiff, Wales, in September 2008, and then at the Kitchen's black-box theater in the Chelsea neighborhood of New York City, some nine months later. After all, what was Michelson, an influential icon of the downtown New York dance scene, doing working with young Welsh ballet students? And, equally surprising, why were classical, Romantic-era references surfacing in her experimental, contemporary work, not the least of which was apparent at the onset with the show's title? From opposite sides of the Atlantic, Michelson created two versions of the performance, each of which evolved into a complex meditation on dance history, the development of a dancer, and how bodies learn, process, and re-present movement information. Intertwined with these themes were similarly provocative questions about what constitutes the "experimental" on the stage.

Michelson was first recognized in the late 1990s and early 2000s for her choreographic style that broke down barriers between the physical languages of modern and postmodern dance, and gestures that seemed more personal than ideologically motivated. Her performances, in playfully subversive ways, questioned valorized notions of dance history through an eclectic choreographic approach. Often her works were distinctive for a seemingly offhand sensibility, although Michelson has always been a highly precise choreographer, calibrating every last detail down to shifting eye movements and the casual flick of a wrist.

With *Dover Beach* Michelson moved away from some of her work's signature characteristics and expanded the stylistic scope of her references, pushing the boundaries of what constitutes dance through different avenues. *Dover Beach* occupies a pivotal place in the overarching trajectory of Michelson's career, as it was the first work of hers, after nearly twenty years of dance making, in which she did not perform. This decision seems to have freed up other facets

of her vision, which steered the movement and design aspects of her work in enthralling new directions.

Chance appears to have played a meaningful role in this development. James Tyson, theater programmer at Chapter Arts Centre in Cardiff, approached Michelson with an open-ended invitation to do a residency at his organization. She accepted without having any particular idea what she would do but knowing that, at the very least, this serendipitous opportunity would allow her to be closer to her hometown of Manchester, England. The initial invitation then evolved into periodic residencies spread out over roughly two years, during which she created *Dover Beach*.

As Michelson recounts it, she initially felt adrift when she arrived in Cardiff—with no particular expectations from her hosts and no plans of her own.[2] This situation is not unusual for her. Michelson is drawn to a research process based on the particularities of the presenting organizations and often works in such a site-responsive manner that her methods, in many respects, more closely resemble those of contemporary visual artists than those of her choreographer peers. In Cardiff she began by trying to understand her immediate surroundings, asking permission to observe a ballet class offered for local youth at the arts center. After one session of watching these eager young girls, Michelson knew she would like to make a piece featuring some of them alongside a small cadre of professional adult performers with whom she had previously collaborated.

There were important precedents to such an approach: two of Michelson's prior works, *Shadowmann*, presented in 2003 in New York at the Kitchen and P.S. 122, and 2005's *Daylight (for Minneapolis)* at the Walker Art Center, had successfully incorporated a number of amateur preteen and early teens girls. Michelson's recurring engagement with young dancers derives in part from her interest in the culture of dance and in questions of the body and process. "When does someone start to become a dancer? How does information go into the body?" she has asked. "What does that look like in a little girl in Wales or in New York? And what about the older, trained dancer? And, what happens if you see those two together?"[3]

Pursuing these investigations, *Dover Beach* evolved into a series of elaborate duets, alternating with lengthy solos, that expressed contrasts between the "naïve" bodies and the "mature" ones. The opening choreography, in both New York and Cardiff, was a twenty-two-minute pas de deux performed by two female dancers with notably different physiques, skills, and performance styles: Non Griffiths, from Cardiff, a wiry blond preteen with no prior performance experience, and Laura Weston, a young twenty-something professional dancer, taller and broader in stature, who had performed in Michelson's *DOGS*, of 2006, at the Brooklyn Academy of Music. The two performers began by executing in tandem the same extremely technical movement patterns: intricate

steps, sweeps of the arms, and sustained leg extensions. Passages presented themselves, seemingly almost reversed, and then repeated again with small variations. Griffiths's performance was somewhat cautious yet extremely intense, marked by a gaze that communicated her fierce determination and the challenging mental and physical work required to learn the choreography's devilish intricacies. The older Weston possessed a more relaxed assuredness that belied the stubborn labor involved in the endless hours of rehearsal. Throughout the performance, other groupings foregrounded striking disparities—including a haunting and suggestive pairing of a younger female performer (Gwenllian Davies in Cardiff and Allegra Herman in New York) with an older male dancer (Mike Iveson in Cardiff and Greg Zuccolo in New York), adding shifting power dynamics into the mix and in subtle ways recalling the famous central pas de deux from Balanchine's 1957 modernist classic *Agon*.

Throughout, *Dover Beach* reflected a new level of movement invention for Michelson, seamlessly combining gestures inspired by classical ballet with those more closely related to modern and postmodern dance traditions, but, of course, reimagined with Michelson's own idiosyncratic details. Recognizable from other works was her strategic use of repetition, which imbued small gestures and actions with dramatic significance. Take, for instance, one movement Griffiths repeated throughout: balanced on demi-pointe, she bent forward awkwardly at the waist, rounded arms outstretched, for several seconds at a time. It was a strange twist on the iconic tutu-clad ballerina standing en pointe with arms elegantly arched overhead; here, the gesture was transposed forward ninety degrees. This was not a classical ballerina projecting a sense of ethereal lightness, performing moves with apparent ease, but rather a dancer grounded in the earthly world, as if burdened with an invisible load. This memorable pose accrued a peculiar weight of perseverance and vulnerability as it reappeared throughout *Dover Beach*.

Such references to nineteenth-century story ballets were not the only ways the work evoked the Romantic era. Romanticism served as a critical touchstone and set the atmospheric tone. It was a means by which Michelson could explore her own British culture and also question what characteristics might qualify as experimental in contemporary dance. "I was curious about representation, the bourgeoisie, that kind of classical art, and what it means to modernity and experimentation," she explained in an interview. "What is experimentation and what is the representation of experimentation on the stage?"[4] *Dover Beach*, she went on to describe, was experimental in ways that ran contrary to popular tendencies within the downtown New York dance community: it was hardly fashionable, she implied, for a choreographer of her background and reputation to summon classical conventions.

The Romantic era began in the mid-eighteenth century and spanned the better part of the nineteenth century, reaching its pinnacle around 1850. It

encompassed a broad range of European cultural and intellectual activities that stood in contrast to the seemingly detached rationalism and classicism of the immediately preceding Enlightenment period. Romantic ideals privileged high emotion as the source of authentic artistic expression and aesthetic experience; feelings of awe and horror and the sublime beauty of nature were newly valued. Equally relevant were pessimistic impressions of the world's growing urban development and industrialization.

Which brings us to Michelson's title, *Dover Beach*. It is, famously, also the title of one of the most iconic British lyric poems of the Romantic era, written by Matthew Arnold and published in 1867—although it is thought that Arnold started the piece earlier, on his honeymoon at the Strait of Dover in 1851. The poem is a melancholic, ambling narrative expressing his dreary outlook on humanity, his uncertainty about the steadfastness of love, and his belief that darkness underlies all forms of beauty.

> Ah, love, let us be true
> To one another! for the world, which seems
> To lie before us like a land of dreams,
> So various, so beautiful, so new,
> Hath really neither joy, nor love, nor light,
> Nor certitude, nor peace, nor help for pain;
> And we are here as on a darkling plain
> Swept with confused alarms of struggle and flight,
> Where ignorant armies clash by night.

This stanza, the fourth and final, is the most oft-quoted passage of the poem, which is itself one of the most cited in contemporary popular culture. Usually, references to "Dover Beach" function as signifiers for literary high-mindedness, evoked with both sincere and farcical intent, and, as such, many of the poem's metaphors have become decidedly hackneyed. In Michelson's performance, the poem was presented in its entirety as a recorded narration, recited in a straightforward, solemn manner by a British male voice. It might be easy to regard the recitation as merely an ironic reference, but it seemed to be lobbed out as both a baffle and a dare—offered up with enough ambiguity that one could not easily dismiss it. While it was overwrought, to be sure, its message, Michelson has said, is also "somewhat true."[5]

Beyond the title, the poem, and the ballet-inspired movement, references to Romantic British culture circulated in the music, costumes, and set. Pete Drungle's score for the work, which he performed live in Cardiff and New York, evoked Romantic precedents, with its lush, rolling piano passages and captivating melodic refrains that lyrically unfolded and resurfaced. Coyly intermixed with Drungle's piano compositions were his recorded soundscapes of

water, wind, and other natural noises that complemented the movement and set. Analogously, Elena Scelzi's costumes were playful, surreal twists on formal British equestrian getups, which one observer aptly described as "hunting habits meet *All That Jazz*." In addition, the Cardiff set featured a painted mural riffing on the bucolic hunting scenes of George Stubbs (1724–1806), one of Britain's most famous Romantic painters, who was known for his expertise with horse anatomy.

Lighting elements were integrated into the set to similar atmospheric effect and in noticeably sculptural ways. The first movement in the show was a mechanical one, made by two custom-made independent lighting fixtures, built from pipes and wood. Self-supporting and anchored to the floor, the fixtures stood tall, like two tree trunks of differing heights. Each was outfitted at the top with a wooden ring adorned with four aluminum PAR can theater lights, which rotated continuously, like a pinwheel, at a leisurely pace. This setup was engineered for only one, almost imperceptibly slow, lighting cue, which very gradually brought the lights up to full illumination over the duration of the show. These fixtures, akin to kinetic sculptures, evocatively played off other Romantic references, suggestive of windmills on the heath, like something out of a Brontë novel, or antiquated, steampunk machinery.

Michelson is well known for creating a total environment, often making intensive responses to the architectural characteristics of her venues. In addition, she focuses as much attention on the set, lighting, costumes, and sound as on the movement itself, working very closely with her chosen design and music collaborators; for *Dover Beach* (as in earlier productions), the dancer Parker Lutz played a significant role in such decisions. In creating immersive works that are dramatic on multiple levels, Michelson generates seemingly autonomous worlds with each performance. This approach could itself be considered Romantic, calling to mind the Wagner-era *Gesamtkunstwerk*— "total work of art" or "all-embracing art form"—which would, ideally, unite the visual, musical, and theatrical arts, though Michelson has explained the phenomenon much more straightforwardly: "First I have to make the scenario that I'm going to make the thing to be seen in."[6]

Connected to this notion of an integrated theatricality is an impressive, Wagnerian sense of scale; indeed, Michelson's performances can be considered almost operatic in their grandeur. Unexpectedly, however, such ambitious atmospheres are counterbalanced by an intimate sensibility, conveyed through elegantly restrained choreography. Perhaps this is why Michelson's performances paradoxically can seem both larger than life and anti-epic. Her simultaneous embrace of such opposing qualities was at the heart of *Dover Beach*, yielding a dreamlike quality apparent in other works too, such as *DOGS* and 2011's *Devotion*.

If such characteristics speak to the similarities between the two versions of *Dover Beach*, their differences were equally relevant to Michelson's creative

process. Although the Romantic-inspired costumes, music, and lighting were consistent in both incarnations, the set and choreography took on different dimensions in New York than in Wales, responding directly to the new context of the Kitchen. The window-filled classroom in Cardiff, for instance, drew connections to the outside, which Michelson accentuated; the Kitchen's black-box space turned her attention toward "interior" concepts. Replacing Cardiff's Stubbs landscape were gray, monochromatic wainscoting details along the theater's back wall, equally suggestive in their own way of historical bourgeois British culture.

Other elements self-consciously referenced Michelson's past work. Perhaps most incongruously, looming high overhead on the theater's back wall was a glowing, aquamarine neon-light sculpture designed by the artist Charlotte Cullinan, outlining a cartoonlike silhouette of Michelson's frontal profile. Akin to a tongue-and-cheek logo, it represented the (missing) presence of the choreographer onstage. The significance of the silhouette portrait has evolved over the years; it has resurfaced in other Michelson works—as an icon sewn on costumes for *Devotion* and, in neon again (the same sculpture), in 2012's *Devotion Study #1—The American Dancer.*

The most prominent new set component in New York, however, comprised two open latticework wooden panel walls made from interlocking circles—a pattern Michelson first employed in the set for *Daylight*, in 2005, but which in this case were repurposed flooring sections from her set for *DOGS.* The latticework screens formed a second, cordoned-off performance area on the stage—a kind of see-through cage—that created a new dynamic of synchronous scenes, diffusing the central focus and generating a relay effect between the two zones. This "cage" enclosed a trio of dancers wearing contemporary leotard costumes, who performed additional, contrasting choreography not presented in Cardiff. It was primarily the type of "experimental" movement New York audiences had come to expect from Michelson, unlike the more traditional-seeming balletic movement elsewhere evident on the stage, which, conversely, at the Kitchen appeared unconventional. This conscious repurposing of set elements echoes Michelson's intermittent practice of reusing fragments of movement phrases from her own earlier work, creating connections between past and present, continuity and change, within her trajectory as a developing artist. Closely related to this tactic is Michelson's frequent transformation of a venue's extant seating configuration. Through the years, she has either changed the setup or created her own seating for shows at the Kitchen, P.S. 122, and the Walker Art Center, among other venues, as a means to alter an audience's expectations before the performance even begins. Although the seating at the Kitchen for *Dover Beach* was the typical arrangement, her choice was deliberate, as the status quo was very different from the prior time she presented work there. For *Shadowmann: Part 1* Michelson had

flipped the orientation of the risers 180 degrees, putting the seating along the back wall, where the stage would typically be. Thus, the audience faced the exit doors leading to the lobby, which Michelson utilized as an extension of the performance space. Analogously, for *Devotion*, her next work at the Kitchen, she had rotated the risers ninety degrees from their normal position so that the audience was oriented along the length of the black-box space, making the stage dramatically long and shallow and again connecting it to the theater doors and lobby, though in a manner distinct from *Shadowmann*.

These decisions about the seating, set, and choreography in the New York version of *Dover Beach* were carefully determined for Michelson's return to the Kitchen, a venue that has occupied a unique position in her career. Michelson not only has presented seven different works at the Kitchen since 1999, but she also served as the organization's associate curator of performance from 2003 to 2005. Since then, she has also periodically guest curated dance events there and mentored emerging choreographers through its Dance and Process program as well as serving on its advisory board.

Beyond her personal connections with the space, the Kitchen's institutional history is a meaningful context for Michelson. Since its founding by video artists Woody and Steina Vasulka in 1971 in SoHo, and continuing through its 1985 move to Chelsea, the Kitchen has been a place where choreographers, composers, visual artists, and theater artists are encouraged to push the boundaries of their art forms to new, often challenging, extremes. Artists as varied as Lucinda Childs, Bill T. Jones, Steve Reich, Philip Glass, Joan Jonas, Meredith Monk, and Laurie Anderson, to name only a few "avant-garde" innovators, all presented new work at the venue at critical points in their careers. The Kitchen's distinguished and interdisciplinary lineage is certainly relevant for the closely interknit New York dance scene with which Michelson is affiliated and which she has helped to shape, both through her work and her curatorial and advisory roles. For Michelson the personal and the institutional come together at the Kitchen to form a kind of artistic home—a grounding place to which she and other artists return and where an ongoing dialogue around work can unfold over time among an intergenerational community of peers.

Which brings us back to that Warholian aphorism and the productive tensions that result from being "the right thing in the wrong space and the wrong thing in the right space," which Michelson activates in both versions of *Dover Beach*. Unlike Warhol, however, Michelson never creates work just for a "space" but rather, more specifically, creates it for a *place*, accounting for specialized histories, peoples, and contexts. The two versions of *Dover Beach* were calibrated for the different cities, sites, and audiences at the Cardiff and New York venues. In both incarnations, Michelson upended stylistic expectations associated with conventional dance traditions, creating works that were in dialogue with various histories as well as the communities in which the

works were situated. From a distanced vantage, *Dover Beach* demonstrates how historical forms can be infused with new relevance in contemporary contexts and challenges received notions about what the term "experimental" may signify in relation to dance. At its very crux, though, when considered at close range, Michelson's work raises much more fundamental questions: What does it mean to be a dancer, and what can a dance be?

NOTES

1. Andy Warhol, *The Philosophy of Andy Warhol (From A to B and Back Again)* (New York: Harcourt Brace Jovanovich, 1975), 158.

2. "I arrived in January of 2007, a month and a half after I'd had hip surgery. I was on crutches; it was pouring down rain; I was staying in a bed-and-breakfast and didn't know anybody. There were no plans at all, not for dinner, not even to show me around—which was very James [Tyson]. Turns out he really did mean, 'Oh, you'll come to Wales and do whatever you want.'" Michelson in David Velasco, "1000 Words: Sarah Michelson Talks about *Dover Beach*, 2009," *Artforum*, May 2009, 112.

3. Michelson in Ralph Lemon, "Sarah Michelson," *Bomb*, no. 114 (Winter 2011), http://bombmagazine. org/article/4721/sarah-michelson.

4. Ibid.

5. Michelson, phone conversation with the author, August 2015.

6. Michelson, in Tere O'Connor, "Sarah Michelson in Conversation with Tere O'Connor," *Critical Correspondence*, September 19, 2006, https://movementresearch.org/criticalcorrespondence/blog/ wp-content/pdf/Sarah_Michelson_9-19-06.pdf.

B-SIDES

Ralph Lemon

May 2012

1. Your work is the whitest work I've seen, of late. Therefore nicely mysterious to a black guy from Minneapolis, Minnesota.

VERY EXCITED YOU WILL TALK ABOUT THIS

2. I'm captivated by the way you honor our national dance canon (not your own?) and simultaneously try to destroy it.

ARE YOU!!!!!???

3. I always seem to find some grace in the exasperation of being an audience to your work.

A LOVELY THING TO SAY

4. From my purview, your work gets better and better. No easy feat. And somewhere in the midst of this you had/have your beautiful daughter, Prudence!

I THINK PRUDENCE FOCUSED ME. I CAN'T MESS AROUND

5. I'm intrigued with your talent in transforming space to hold your ideas. If you had your own space, what would it be/look like? Or is wrecking existing spaces to do your bidding the point? (A Gordon Matta-Clark of the dance world.)

HUH?

An artist known for works that radically altered existing structures. He called himself an Anarchitect!

I WOULD LOVE MY OWN SPACE
HUGE
WINDOWS

BUT ROUGH
BUT TRULY I THINK THE WORK COMES PARTLY FROM THE
POTPOURRI OF ENVIRONMENTS THAT IT GROWS IN. SO I
TREASURE THAT

6. In all the works I'm familiar with, there seems to be these outright wrong moments in the whole of the other really good stuff. And I often walk away loving the wrong moments more than the brilliance . . .

GOOD!

7. I find the work very sexy, like a guy made it, a straight guy!

FANTASTIC

8. What do you call yourself? A choreographer, or what?

A CHOREOGRAPHER

9. I find the voluminous doubt that you often publicly announce about your practice (mostly in print) very curious.

I AM ENVIOUS OF YOUR CLARITY AND SURETY

10. When I think of your future it makes me happy about contemporary dance (or whatever it's called these days).

SHIT

Which brings me to my prediction: that after your MoMA Atrium experiment this year—which will no doubt be a challenge because you can't alter its space the way you have other spaces in the past (your brand)—after MoMA, which follows your piece for the 2012 Whitney Biennial, which followed *Devotion* at the Kitchen in 2011, after these three dances and debating spaces, I believe you'll have enough information to take us all well into the twenty-first century, with a form of performance, dance, beyond theaters, galleries, museums . . . if you so choose.

So imagine: Can you describe this place, places, this dance, these dances, and this future?

JESUS

*

In 2006 I asked Sarah Michelson if I could suggest a dance, or a set of parameters in which to make a dance. I didn't really know her, but I had heard of her. Hearsay, mostly. Saw some work in 2002. I was impressed and suspicious, both of which are generative qualities in viewing work. Mostly I was impressed. I noted an obscure compositional style I couldn't place. One that kept scratching at itself. I approached her with a project I was curating, one where she would have to collaborate with some other artists: another choreographer and a visual artist. I thought it was an interesting enough project and that she was an interesting artist. But, like I said, I didn't really know her. The initial proposition was complex and naïve. But I had a hunch, and she was game and said yes, with some caveats. "The project's main components are things which I might usually reject right away," she began in an e-mail, continuing:

> A Visual Artist who will create the stage scenario. I usually create
> all sets with my collaborator Parker Lutz and they are central to my
> work making; A subject for a work, which has not come from me,
> has nothing obvious to do with me and which could appear to be
> another easy art marketing scheme that it seems obvious to run a mile
> from; Another performance maker with whom I share the set and
> potentially the concept of the evening. (Deborah Hay who I respect
> greatly and of whose work I am slightly afraid). None of this suits me
> as a dance-maker at all and in agreeing to this project I have already
> begun to deeply question how I work, how I will apply my principles
> of beauty and austerity to this structure, and what new discipline I
> must construct to fulfill this complex stage problem. Is it possible for
> me to present a pure image of a dance of mine, and feel the peace
> that comes for me with only that, in this circumstance, where my
> control will potentially be mined by collaboration? Can this collabora-
> tion be thorough enough to disallow compromise? A rare opportunity
> to work.

I thought this was a friendly enough response. Expected as much. I thought she'd be good for the project's goal, which was to (productively) confuse people about where they were and what they were watching. Sarah is good with secrets. In this response, she didn't mention the very loaded music quotient I'd proposed, along with some other constraints. After the initial invitation, she and I never really talked about the music prompt again. From this clandestine agreement came Sarah's *Devotion Study #3*, which was performed as part of Some sweet day, a dance series I co-organized with curator Jenny Schlenzka at The Museum of Modern Art, New York, in 2012.

The 2006 project had begun as a chance to curate a dance series at the Institute of Contemporary Art, Boston, as part of an exhibition they were putting together on American blues music. I thought, well, I don't want to racialize it, but they're calling me because I'm a black artist, probably thinking I might have some relationship to the idea of the blues, which I do. But that part didn't interest me as much as curating a series of dances, something I had never done. I thought about creating a framework where a performing artist would work with a visual artist from the exhibition on some kind of structure that would inhabit the theater. Then I thought of pairing performing artists. I was interested in having two very different performing artists in the same place at the same time, to give them and the audience some historical or aesthetic point of view or tension to work and watch from, a collision of my choosing and, in some cases, of my obsession. I thought of artists like Sarah and Deborah Hay, two generationally iconic and very different women makers.

Long story short, it never happened. But it remained a kind of bee in my bonnet. And then, a couple years later, the curator Connie Butler invited me to be a part of the 2010 exhibition *On Line: Drawing through the Twentieth Century* at MoMA. I had done a very personal, practically private, duet with Okwui Okpokwasili at Danspace in 2008, and I remapped that work for MoMA's hyper-public Donald B. and Catherine C. Marron Atrium. The Marron Atrium is a large open platform at the center of the museum, designed to be indeterminate. It is obviously not a theater—at least, not a traditional theater—in that relations between performers and audience are less scripted, if they are scripted at all. The performance at MoMA was surprising, and it changed the work, of course, but also my idea of how to be in my body in front of that kind of unwieldy audience, an audience so at odds with itself and with the space. There were at least three different audiences—people from the dance world, who came to see me and Okwui; people from the art world, who came for the event; and general museum visitors, who roamed through the space incidentally. It was extraordinary to have all this present simultaneously.

I wanted to do it again, differently. After the 2010 performance I wrote to Kathy Halbreich, the museum's associate director, and said I'd like to bring my 2006 ICA idea to MoMA. Kathy loves dance, when well made, unmade—the challenge of it—and she was thrilled about all the artists I mentioned, including Sarah. She opened the door to the museum but advised me to get rid of the visual-artist collaboration. "Just do the dances," she said. She was right. Then it was a matter of refining the original idea. A three-week program was planned for October and November 2012. Each week would feature performances by a pair of choreographers: Steve Paxton and Jérôme Bel; Faustin Linyekula and Dean Moss with visual artist Laylah Ali (this week would also include a two-day performance by artist Kevin Beasley); and Deborah Hay and Sarah.

The most important problem was how the dancers or choreographers would deal with the Atrium. The other curatorial prompts were: "Think about the pairings. Let them affect your choreographic situation or ignore it." And, finally, "What is

black music?" This last prompt—the loaded music quotient, the secret that Sarah and I had never really talked about—had grown out of the ICA proposal. It was a trace, or recycled element, of the original concept that could expand and/or evaporate.

At the time, I was compelled to upend the inherent fictions of the blues, this black music. It was more interesting for me to think about how Charley Patton and Sun House were genius innovators riffing off everything around them—yes, black America and profound racism, but also a culturally promiscuous white American culture, Native American culture, Mexican culture, etc. The early blues as we know it happens to be black music because someone recorded it that way, found a way to merchandise it. Before the music was labeled separately, white and black, musicians were playing the same music, basically, I'd like to believe. So I thought maybe it would be possible in Some sweet day to keep the black-music element a secret, unannounced (an Easter egg of sorts). A way to destabilize its cultural placement. A private interrogation between the choreographers (the dances) and myself. The "Yes" or "No, it doesn't interest me" would also be an important, mostly unspoken, tension. This curatorial intervention was not really about the blues or music or race; instead it would be an internal marker, activating some kind of compositional body reaction, if only a blip. That was my hope.

Sarah and I didn't have an in-depth conversation about any of this as she worked on *Devotion Study #3*, but I would send her songs I was listening to, impose a few I was in love with, that I thought she should hear: Nina Simone singing "Who Knows Where the Time Goes," a Sandy Denny song. Carol Jones's "Don't Destroy Me," Doris Duke's "He's Gone," Shirley Ann Jones's "There's A Light" . . .

I will look forward very much to getting the song!!

Sarah was always very polite. Each and every one of them was avoided, I'm sure.

In his 1963 essay "Jazz and the Black Critic" (published in the anthology *Black Music* in 1967), LeRoi Jones/Amiri Baraka wrote:

> As one Howard University philosophy professor said to me when I was an undergraduate, "It's fantastic how much bad taste the blues contain!" But it is just this "bad taste" that this Uncle spoke of that has been the one factor that has kept the best of Negro music from slipping sterilely into the echo chambers of middle-brow American culture. And to a great extent such "bad taste" was kept extant in the music, blues or jazz, because the Negros who were responsible for the best of the music were always aware of their identities as black Americans and really did not, themselves, desire to become vague, featureless Americans.

Black middle-brow American culture.

Today I think of the (fading) middle class (in concept, the one that does the conceptualizing, the creating, the consulting) as a colorless class, along with its post–World War II origins and the nostalgia and mythology of the term and category. There is a growing but small number of black folk in this elusive class, and, like other racially marked middle-class American households, they are receding in the culture. "Near poor" is an appropriate description for the whole of this class. Although its members may not own much, they can appreciate museums—an airy privilege, a leftover awareness and placement from whatever upwardly mobile myth momentum did exist. This is where the tiny artistic avant-garde (whatever that is, whatever that means today) resides and the miniscule black avant-garde vigorously reacts to the predominant (and also fading) white male art world.

Bad taste, acting out, that culture.

What is most interesting to me is the inversion of a black acting-out response to racism, in all its many nuances. Maybe it has always been the case that this fundamental transgression becomes global popular culture. American music makes the best example: Charley Patton, Sun House, and Mamie Smith become Elvis Presley, who becomes Jimi Hendrix *and* Lou Reed. And, speaking of Lou Reed, there's another parallel line: Louis Armstrong becomes Charley Parker becomes Ornette Coleman becomes Lou Reed becomes Patti Smith becomes Beyoncé. (While D'Angelo becomes D'Angelo, becomes D'Angelo.) Acting out, this morphing bad taste, and the extraction of its transgression, is a fundamental part of our functioning creative American society. Western modernity and its requisite racialization need this acting out, the performative black body, yet again, whenever possible (and when onstage or in an arena, all the better).

Transgression ultimately becomes inclusive and practically benign, available to everybody, and it makes money. Jay-Z and Beyoncé made art in and about their particular ghettos and then became king and queen of the whole wide world! So much for the avant-garde. Black culture and its food source, capitalism, have become a gargantuan black snake eating its tail. What a wondrous and, in a way, generous phenomenon. Capacious. The whole wide world.

And Sarah Michelson.

Devotion Study #3 ("Bad Taste" and Acting Out in the Atrium)

Passing through MoMA's lobby and then darting, spritely, up the stairs to the second-floor Atrium was Nicole Mannarino, wearing navy-blue bubble shorts and a royal-blue Lacoste short-sleeved top and white tennis shoes, hand-in-hand with Tyrese Kirkland and Gary Levy, two members of her physical chorus of black museum guards—an exhilarating entrance to begin *Devotion Study #3*. The

empowered, proud, black, smiling guards surrounded a young white woman with her hair tied back into two strawberry-blond Afro bunches, guiding and protecting her. The audience erupted in applause, of course, like they already knew the show. And she was fierce, hip, soulful, austere, sexy, and also innocent. Maybe worth the attendants—it seemed so. Her verve, these men protecting that verve. The whole moment desexualized and a stark perversion of the historic imagined threat. How was that possible?

And then her steps, all by herself out on that hard Atrium floor. Some kind of truncated jazz steps, I first thought, but the rhythm was wrong and stuff seemed to be missing; it was catalectic, not predictable. The steps, anti-geometric, inscrutable, were placed precisely in the space. It was at odds with the very round 1960s and '70s Tamla Motown sound being DJed by none other than the master, mother, Sarah Michelson. Quick and bouncy stepping, the rest of the body mostly upright, vertical, her arms clasped behind her or on her hips, with sudden bursts of athleticism, big kicks, multiple spinning turns, and the occasional imploding splits to the floor. A choreography of gaps. Not like black people dance to this music, where there is heavier gravitas and flow. Nicole was all scatty joy, fear as joy, challenged, giddy, a feat. When I was a teen dancing to this kind of music, I didn't feel giddy but more like I had to prove something, some kind of ancestral conversation, but innocent as well, a grounded innocent rhythm in my body. Nothing like Nicole or like James Tyson, the second dancer, a punk, Puck-like presence, mischievous, shirtless in tight black jeans, white (pink) skinny skin blazing up and down through MoMA's floors, other white spaces, unseen most of the time, appearing suddenly at unexpected moments. The same movement as Nicole, when he was seen, the same odd rhythm. A similar cultural discombobulation.

I was reminded of George Balanchine, of all people, and of 1957's *Agon*, in particular. How the jazz of the body he incorporated (imagined) into that dance's central duet was not like the body jazz of black folk, where some of it came from—even with Arthur Mitchell, an aberrant black ballet dancer on whom he had built the choreography, dancing it alongside a white ballerina, Diana Adams. How (appropriated) "bad taste" becomes formal. Sarah dressed in white from head to toe, white men's shirt, white skirt, white converse sneakers, standing at her console for all to see, bouncing her head, singing and occasionally shouting along to the music, this very black music. She knew the music, obviously. And it was in her body, spirit. An ardent agency. *This is my shit.*

During Sarah's rehearsals, before I knew what the museum guards were doing, I asked one of them what she was like to work with.

She's very good.

Huh?

She knows how to talk to us. We like that. And we'll try to do whatever she asks. We are devoted.

What do you mean devoted?

She respects us; we respect her. Otherwise we can't do our work.

How does she talk to you? And what does she ask?

She's good, that's all I can tell you, is all he said. This tall handsome brother, costumed in his museum-guard black.

I didn't say much to her the few times I dropped in to watch her rehearse. It was thrilling to watch Sarah, who controls everything, try to figure out how to control this thing she couldn't control. Yes, I took some pleasure in watching her struggle, like I had struggled in the space two years before. We talked about that. For Sarah it was par for the course, this annihilation of systems, hers and the system's. She didn't seem fazed. Once I brought up the question of how the work could or should be watched by an audience. It seemed a fair enough question given my organizing role. She ignored me, didn't seem to care, and in fact put up psychic obstacles to keep me from forcing the issue, like, "I can't talk about that right now, it's distracting . . . " A few years before this conversation she had told me, *I have an audience of like four people, truly, in my heart, and I'm one of them. And my work is for those three people and me.* (Bullshit.)

 In the end she did care, and she ultimately obfuscated how the work was seen. A few rows of standard black-leather MoMA benches were set symmetrically against the inner Atrium wall for select people (family, friends, and early arrivers) to sit on and watch the performance, gazing out at the balconies and sculpture garden and Nicole's shifting steps, movement in the vast white Atrium expanse. The other onlookers were on their own—they made do, or not. I watched from the second-floor bookstore, maybe the best place to watch the dance. That's what I told Sarah. I knew, because I had spent a few days studying the question.

Whatever, she said.

This "whatever" is a nice problem. She says she really only cares about a few people seeing the work, and the rest, the many of them, the growing many of them, get short shrift, an aestheticized alienation. Purposeful, I'd like to think. Although Sarah would never admit it.

A year later, I had a dream about *Devotion Study #3*. In the dream I'm in bed with my lover, who's trying to describe the dance to me.

Letters . . .

Drawings . . . Choreography . . .

Be a man! she said, lying next to me, not really wanting to wake me, but maybe she did, borrowing a lyric from a song a famous choreographer had danced to a couple years before at MoMA, whose name she wouldn't mention because, she said, it would make this part of the dream too topical.

A Brit with soul, she continued—*I can tell you that much—Northern Soul, Manchester, the ghetto. Have no idea who the black woman was singing the song, American for sure, Detroit, maybe. But that Brit girl can make a dance! Whitest choreography I've ever seen. A new black.*

Young white Brits are often blacker than white American kids. I wonder why? More eman- cipated, perhaps.

Huh!?

Cause white Brits are whiter than white Americans, so white they can hold any color.

What!? That's silly.

But you know what I mean. You know:

Now I've drunk a lot a wine and I'm feeling fine / Got to race some cat to bed / Oh is there concrete all around / Or is it in my head?

And

Mama, just killed a man / Put a gun against his head / Pulled my trigger, now he's dead.

OK, Mott the Hoople/Bowie, I get. But, hon, is Freddie Mercury technically a white Brit? Since he was Parsi and born in Zanzibar, grew up there and in India?

Well he projected white Brit, was world famous as a white Brit, which is enough to make my point. Anyway, they got hold of our B-sides before we did. Were proud of it. In 1975, David Bowie was totally pimped-out on Soul Train. *Totally pimped out! And wasn't even embarrassed.*

But we can love oh yes we can love.

I incorporated this dream into a performance I made in 2012–14, *Scaffold Room*, a work in part about pop divas, black and white.

Maybe Sarah is furiously determined to not become a vague, featureless American choreographer, as much as she says she loves this place, the (fading) American (middle-class) contemporary choreographic scene. A vague, featureless American she will never be. And the work can only exist, be made here, in this miasmatic American place.

Nice to be an outsider.

I didn't always think of Sarah Michelson as black. Not in the beginning. *Grivdon at the Grivdon Concrete*, 2002, at the Kitchen. What the fuck did that title mean? A dance sketch I saw (with Parker Lutz, Greg Zuccolo, Mike Iveson, Tanya Uhlmann, and Tony Stinkmetal), a precursor to her famous *Shadowmann* of the following year, which I didn't see. At the time, as I mentioned, I thought she was very interesting, and very interested in some kind of subversive fashion statement (misplaced Dolce & Gabbana logos), fashion-method as a way to scream, yell at somebody, us the audience, stylistically. The method didn't seem gratuitous, but it was definitely in disguise. I wasn't used to white women being this much in your face (like a lot of black girls I grew up with). It was not until I saw *Dover Beach* at the Kitchen, in 2009, that I began to put it together, to think of Sarah as black. It was the "whitest" choreography I had ever seen downtown, below Forty-Second Street. I couldn't figure it out, why it was so white, a hard-white, accented. Maybe because of the title, *Dover Beach*, and the upper-middle-class "hunting scene" choreography, and the fact that Sarah is a Brit, a northern Brit. You know, *Wuthering Heights*, Brontë, Heathcliff, white little girls, Northern England, moors (different moors). And The Fall, The Smiths, New Order, Joy Division, Buzzcocks, Morrissey . . . Mancunians. Yeah, *Dover Beach* was clearly a love story.

If you go online and look up Grivdon, a bunch of Northern Soul YouTube videos appear, uploaded by "grivdon." Her homeboy, homegirl, something like that. Northern England, Manchester, Madchester, her ghetto. Where Sarah grew up. A particular kind of "near poor" (*working class with middle-class aspirations*) and their soul clubs, the late 1970s. Wigan Casino. Rhythmic black soul-music dancing by Manchester locals, Thatcher white trash, post-Empire poverty-privilege, that whiteness, appropriating because they felt like it, because they could. Not dancing like black people but dancing to the B-sides of black music that black Americans weren't even listening or dancing to. *Fuck 'em, it's ours, they don't even know this music exists*, they seemed to dance.

Bopping, a vertical wiggling, hyper-rhythmic, funky, entitled.

Nicole dancing a translation of Sarah's Northern Soul recall in the anti-soul white blaze of the Atrium. Sarah behind a sound system, DJing. Singing along to the songs. Nicole, an American modern dancer being pushed beyond what her body understands, even the intergenerational pop of it, a white cultural divide, how exciting! Two very different modern white-girl worlds. Sarah knew the black music more, more than Nicole, more specifically than me, these B-sides, although I was immediately in love with the sound, knew it in my bones, wanted to dance my own dance. There is a B-side to every A-side. Yeah, Sarah Michelson is black, because I say so. Like Deborah Hay is black, and Steve Paxton, like Bruce Nauman is black, because I say so, and Agnes Martin and Herman Melville and Kathy Acker. And Frank Zappa, Captain Beefheart, absolutely. And Andrei Tarkovsky, how I love all that dark, deliberate mud! All my favorite artists are black, by the way, the really good stuff, because that makes my life easier to think about. An elemental reverse-appropriation in response to an infinite quotient of different kinds of appropriations that have everything (and nothing) to do with me or my work, by really good artists. Yes, let's say that all oppositional acting out is black. We could call it a few things, I guess, but for my argument let's say black, just to keep it simple and liberal.

Sarah once told me that when she moved to San Francisco, in 1987, she saw a flyer on a notice board in a feminist bookstore that read, "Woman of color, wanting to meet the same." Sarah answered the notice, left a message at the number listed. But the woman never called back. Sarah was serious, a *woman of color*.

Yeah, I thought, I'm not in the mold.

Sarah was nowhere in sight after the final performance of *Devotion Study #3*. But at last she arrived, near the end of the after-party for Some sweet day, in MoMA's employee café. She seemed exhausted, rattled, holding tight to Lutz like a lover, her best friend and collaborator, her protector, or one of them.

The whole thing was weird, she said. Her face full of catastrophe. Her voluminous doubt.

But this doubt is, of course, material, becomes a kind of fierce generosity and theater, the next work. How she cares. And how she calms down, becomes charming in between the moments of crazy disrupting passion. Honoring, wrecking, honoring, wrecking, honoring.

"What do you think now? How do you feel about it now, that dance in the Atrium? It's been three years," I asked her recently.

It really changed how I understood perception. It was amazing to experience the wind of the canon blow me and Nicole to smithereens.

This humility surprised me. The wind of the canon. Yes, the whitest choreography I've ever seen in the whitest ante-performance-space I know. (Indeterminate architecturally, but quite particular otherwise. I was told a few times that I and the museum guards were the only black bodies in the Atrium during some of the rehearsals and performances for Some sweet day. The fact slipped by my own gaze. I had to be reminded, was mostly preoccupied with the culture[s] of choreographic matters, the blackness in and not in the dances, that particular gaze.) Sarah standing in place, watching the whole thing watch itself, defiant, for all to see, in, perhaps, a perfect resistance. Sarah breaking her own (successful) rules. The sparseness of *Devotion Study #3*, how architectonically uncertain, unwieldy, unfinished it was, how scared and recalcitrant Nicole's dancing was, with and because of the sanctified museum-guard protection she had, those dressed-up holy black men. And the (specific) black music, of course, hers, all hers, music I knew but couldn't name, encouraging and disarming the acting out. The chorus inside a white(ness) vortex void. A void vast and empty, ravenous and loud. A white wider and harder than its delirious black heart.

It became my favorite dance of hers, until the next one, and the next one, and the one after that: the live public experiment(s), the work expanding and contracting. Her human-messiness exactly danced, hyper-repetitive, private and spectacular, competing with itself, its own hermetic scoring, where outright winning is impossible, that kind of experiment. How close to emphatic failure they have come, could be, the spectacle of that. But it doesn't happen, not yet, always leaving a trail of disbelief. An ending right at the precipice.

SPLIT CITY

David Velasco

Well, as we say today, that is what you pay for New York City.
—Elizabeth Hardwick, "Cross-town," 1980

By the time Sarah Michelson came along, the whole uptown/downtown thing was getting a little iffy. But to the degree that this mythical divided New York has persisted into the early years of the new millennium, Michelson is one of its central protagonists, having become, in a relatively short time, an avatar for a sensibility we still stubbornly call "downtown." In 2002, around when Mikhail Baryshnikov saw her *Group Experience* at P.S. 122 and commissioned a piece for his own White Oak Dance Company, the critic Gia Kourlas wrote that Michelson "is a serious artist who has the potential to lift the downtown dance world out of its cute and self-mocking rut."[1] By 2005 the *New York Times* was arguing that "she commands an avid downtown following, wins plum commissions and basks in critical acclaim," and as of 2006, the *Times*'s chief dance critic, John Rockwell, was calling her "a kind of uncrowned queen of downtown contemporary dance."[2]

The true measure of a queen might be not adulation but dissent. In 2005 the *New Yorker*'s chief dance critic, Joan Acocella, in an article on four choreographers whom she notoriously labeled the "downtown surrealists," complained that "of all the neo-surrealist work I've described here only Michelson's seemed to deploy its enigmas *against* the audience."[3] And by 2014, Alastair Macaulay, another chief dance critic, again in the *Times*, was crowing that "to applaud [her dancers] is like applauding galley slaves for their hard labor," arguing that Michelson "emerges as the most pretentious artist of my entire experience, and among the most self-infatuated."[4]

At the very least, we can all agree that Michelson merits superlatives. So what does it mean to be a "self-infatuated" queen of downtown dance at this time in history?

Some critics have linked Michelson to that generation of choreographers marked as "Judson," after a series of low-key, high-stakes dance concerts held from 1962 to 1964 at Judson Memorial Church in Manhattan's Greenwich Village.[5] And, indeed, Michelson does share something with those pioneers of so-called postmodern dance: a suspicion of insincere artifice or conventional theatricality, an affinity for making things with and for friends, a frequenting

of certain downtown venues—including, among others, Judson Memorial Church. And certainly the environment in which Michelson creates dances has inherited the Judson group's oppositional sensibilities. But the analogies, I think, end there.

For is there a "downtown" choreographer who has been more vigorously, actively engaged with glamour and the transcendence of the star image, with a tectonic but devoted recombination of ballet and modern dance styles, with decor and the sentiment of music, with the propitious excesses of spectacle, with the heroic climaxes of narrative, with beauty, with *style*? In other words, with most of the things deemed démodé by the Judson dance makers, at least as their lessons, passed through the cynical and amnesiac alembic of history, have arrived to us: in the form of Yvonne Rainer's infamous "NO manifesto" from 1965 or, to quote Macaulay, as a "concentration on pedestrian vocabulary and repetition."[6]

The fixing of Michelson in a Judsonesque tradition, conflating her "downtown" (mostly East Village and Chelsea) provenance with the (mostly Greenwich Village and SoHo–based) group that helped define that precinct's earlier sensibility, is understandable. But it misses a larger point. For the venerable, phantasmatic downtown that Michelson inherited in the 1990s and 2000s and whose horizons she interpreted and helped reshape was a downtown whose physical realities—the social fact of artists living and working within its zones—were mostly exhausted. Simply put, the scrappy, young, unsubsidized dance maker moving to New York City in 2017, the kind who might once have constituted the "downtown" scene, will not move to Greenwich Village or SoHo or TriBeCa or even the East Village or the Lower East Side or anywhere in Lower Manhattan. She will move to Bedford-Stuyvesant or Bushwick or Sunset Park in Brooklyn, or Ridgewood or Sunnyside in Queens, or Jersey City, across the Hudson. Or she might move instead to Paris or Brussels or Berlin— cities supposedly winterized against the cold vicissitudes of gentrification and privatization—and travel to New York for the occasional showcase. To speak of "downtown" now is to speak of an anachronism.

If this is important, it's because the story of modern and postmodern dance is largely an island story, a story of New York's ideal and real estates and how and where the city's bodies move and jostle with one another, how they carve places out of its mythic terrains and organize themselves along its riven image. As the "downtown" purlieu is displaced, so is a way of being with others, an entire world of habits and mores and formats of art making.

The whole drama of art in New York has been staged according to this essential fact: It is imaginable that, from any point along Manhattan's spine, you could walk from one side of the island to the other. It is a place uniquely equipped for walking, for a kind of thinking produced and loosened by walking, for a dance of walk/don't walk. The city's sense of itself filled with solitary walkers in the delirious grid, of being able to apprehend the width of the city but

not its height, is what projects this image, beamed meaningfully and powerfully around the world, of a city that moves easily from side to side but which is split between an uptown and a downtown. This geography imposes its own peculiar ontology, a productively "vertical" thinking.

If you take this Split City seriously, as I do, then to call Michelson a queen of downtown at a time when "downtown" is more ideation than home—when it floats unmoored, synecdoche detached from any physical referent—is to consider her royalty in exile, a fallen angel of real estate.

If anyone knows the power of place, it is a choreographer: someone who deems action within a space. The term *choreography* has in recent years detached from dance and, like *curate*, has been abstracted and exported and instrumentalized (gentrified?) for other professional gambits. I can't help but wonder if this is tangled up with an abstraction of space generated by, or at least in concert with, recent crises in real estate. In New York a spasm of capital has broken "place" into units to be securitized and auctioned and traded in a development bubble built on the systematic exploitation of . . . everyone. The city is pocked with dormant condos that function not as places to work and live or as incubators of interclass contact but as networking facilities and vacuums of capital. Not places at all, but blank spaces.

A few years ago Michelson made a dance called *Devotion*. How this came about and where her subsequent devotionals brought us are the principal subject of this book. The other subject of this book is New York, where modern dance was born and grew up and—pending a second coroner's opinion—died, a story *Devotion* and its sister dances metabolize and electrify. If I am right, Michelson's Devotion works are as much a group of dances as another way of looking, a New York way of looking. By which I mean, at this point, a way of looking after the great migration: a New Testament for the dance diaspora. If I am right, maybe I can convince you, too, that being here at this moment with this work means something, that this devotion is spectatorship by other means.

I'll Be Your Mirror

"The place where the work will happen is pretty much always my starting point," Michelson has said. But when the Manchester-born choreographer moved to New York in the late 1980s, that starting point was already split, multiplying. In 1989 a friend took her to see a John Jesurun play at the Kitchen, just three years after the venue had moved from SoHo to Chelsea. Jesurun had twisted the space around and made it all fucked up, but Michelson didn't know that yet, because it was her first time. She didn't know that this would be the first of many proliferating sites she would learn and inhabit and where she would produce some of the most significant dance work of the early years of the new millennium. It was simply the first theater she went to in New York. When she

left, she had "a strong memory of that place, and of walking from west to east after that show."[7]

In Split City things get divided more or less unevenly—even and especially "ineffable" things, like attitude and form. "The site-specific was preferable to the class-specific," T. J. Clark has written about certain shifts in New York art in the 1960s.[8] As if those things are ever separate. New York gives the lie to the notion that site and class are distinct. Michelson's attitude came from a feeling for place—she often refers to her venues as "landscapes" and her position as a "viewpoint"—dislocated but forged by an underclass, underdog attitude. Soon after arriving in the city, in 1989, Michelson left again, for San Francisco, then New York, then Madrid, and then New York again, where she would stay for a long time.

It's March 2003, and the Kitchen is twisted around again, flipped. Black Masonite floors, black brick walls, exposed lighting tracks—same as usual. But everything else is off. The seats are on the wrong side, the bleachers crowded against the building's south side so that they face north, toward the theater's entrance. There's no decor, just an elevated sound booth upstage, to the west, and a platform stacked with chairs—phantoms of the erstwhile audience—upstage east. You walk across the black stage to find your seat, and then there you are, looking back at where you'd so often been before.

The dance, *Shadowmann: Part 1*, has already begun: a fragment from the beginning of Uriah Heep's "The Shadows and the Wind" plays on repeat, an overture, while five young girls dressed in T-shirts and minidresses emblazoned with Dolce & Gabbana logos stand scattered like sentries across the stage. When everyone's seated, the girls crowd in a downstage corner, *repoussoir*, and begin a slow, repetitive dance that a serious Kitchen habitué might recognize: Michelson's *Grivdon at the Grivdon Concrete*, of 2002.

Two attendants are posted at the front doors. They swing them open, and powerful HMI lights outside illuminate West Nineteenth Street. Two women in yellow jackets, white stockings, and high heels appear on the doorstep across the street and begin walking toward you. When they reach the lobby they lie down, take off their shoes, and pitch them back outside. A truck passes. And then: fierce crossings, ritualistic battements, stiffened diagonals, fog, cinematic lighting. It is a mad, precise dance that, in addition to claiming space outside the building, expands to fill the whole of the Kitchen. Dancers dance in the lobby, the corners, the control room upstairs. (The core dancers now commandeering the space, in addition to the young girls, are Michelson, Jennifer Howard, Mike Iveson, Parker Lutz, Tanya Uhlmann, and Greg Zuccolo.) An older man—no doubt familiar to many in the audience, for he is a frequent spectator at downtown performances—stands on the mezzanine above the front doors, presiding over and sometimes even seeming to conduct the movement below, reaching

down in an exaggerated scooping gesture that, minutes later, metastasizes and convulses through the dancers. "I . . . am . . . Henry . . . Baumgartner," intones a voice over the speakers, and then the lights shine so bright they blind you; the doors, which have been used for entrances and exits throughout the performance, swing open again; and the D&G *Grivdon* girls walk out toward the sidewalk and into a white limousine, which pulls away into the night, heading east. "Maybe they're on their way to P.S. 122," Deborah Jowitt writes in the *Village Voice*.[9]

Shadowmann: Part 2, performed a couple weeks later at P.S. 122's smaller theater space, is a quieter, intimate dance—a kernel of *Part 1*. There's white carpet on the floor, kitschy floral drapes along the walls. The costumes are less fetishistic, more boudoir. Many of the movement phrases—rapid-fire karate chops, one-legged chair poses—that form the skeleton of *Part 1* return, but here they also seem to retreat, like a star collapsing in on itself. There's more stasis, kneeling, contact, touching among the dancers. It's cramped, and they spend less time crossing the space—where would they go? After about forty minutes, the drapes are pulled back to reveal a tiny girl in a gossamer blue tunic dancing on a platform outside the window. Iveson, Lutz, Paige Martin, Michelson, and Zuccolo have formed a tight pack near the fire exit. Iveson screams and they pour out the door; you see them through the window walking solemnly in a procession down the street. Maybe they're on their way home.

It is wrong to say that a dance is "about" something. (When asked what one of his dances was about, George Balanchine would deadpan: "About twenty-eight minutes.") Such assertions encourage the fantasy that dance can function according to the same logic and rhythms as a television pilot, that the mechanics of movement and choreography might in fact bear some resemblance to the operations of plot. But *Shadowmann: Part 1* is about something. It is about place.

One of the many radical premises of *Shadowmann: Part 1* is that it makes the Kitchen itself and, furthermore, the audience of the Kitchen and the loose network of dancers and artists comprising the broader, intercontinental "downtown" dance world subjects of the work. The theater having flipped on its axis, the audience, quite literally, faces itself. It uses the same entrance and exit as the dancers. One of its own, the critic Henry Baumgartner, is among the performers, guiding, watching, prompting. And another dance that happened there, *Grivdon at the Grivdon Concrete*, lives again. You can look back and see a history of dances behind you, your comings and goings. You can imagine a young woman arriving at the Kitchen in 1989, not yet knowing how imbricated her life and this place would become.

Part 2 both sustains the premise of *Part 1* and elaborates it, drawing a line between east and west Manhattan—a psychosocial topography—that also defines for a while the contingent, ambiguous world of downtown dance. The work as a whole points to a dialogue between the Kitchen's somewhat tonier,

more remote black-box space and the grittier East Village bastion P.S. 122, which is home court for many dancer-choreographers affiliated with the downtown milieu. "*Shadowmann*'s aesthetic stems from a closely observed world of thirty-somethings living in confined quarters in urban enclaves where creativity and dreams battle the banality of ordinary life," RoseLee Goldberg writes in her *Artforum* review.[10] These "confined quarters" of 2003 are a long way from the shabby yet capacious SoHo lofts that served as the spatial and psychological ground zero for much of the New York dance demimonde in the 1960s and early '70s—so much so that in 1974 Annette Michelson (no relation) referred to the area south of Houston Street as an autonomous zone, its insularity directly conducive to a self-critical sensibility: "Existing and developing within their habitat as if on a reservation," the neighborhood's "consumingly autoanalytical" dancers were "condemned to a strict reflexiveness."[11] The confined but relatively concentrated dwellings of 2003 are a longer way still from the more thoroughly dispersed, Brooklyn-centric New York dance world of the 2010s.

Michelson does not make dance for just anywhere, for just anyone. "These dancers, this music, here, now," Balanchine used to say, though popular and patronal taste forced displacements into the more pragmatic register of *there* and *then*. But these are words that Michelson, who hasn't often had to address the demands of a massive, possibly alienated, public, continues to live by. "The shows themselves aren't just about dance steps," she tells Kourlas. "They're about the people who are doing them and where. If it works, it'll be a little bit magical. I don't know how much longer I can keep it up, but I really like surprises, and I think that undoing the expectations of your own theatrical community is important."[12]

Not for just anywhere, not for just anyone. *Devotion*, which premiered at the Kitchen in January 2011, was Michelson's first dance since the death of Merce Cunningham in 2009, and in many respects it is a homage to him, or to his legacy; to her time as one of his students in the early 1990s; and, perhaps, to the model of dance making and dance preservation that he both epitomized and modified. It is a dance that conjures and twits creation myths.

The Merce Cunningham Dance Company—still resonant despite having closed two years after the death of its founder—may be not only the paradigmatic living, thriving modern dance company but also the last example. The company-and-repertory model of transmission, in the modern, Martha Graham–Cunningham–Balanchine sense, is no longer intelligible to many dance makers. The development of the kind of idiosyncratic technique that forms the backbone of many singular repertories—a living system of habits, stretches, and repetitions that work the body into a particular kind of attention—seems an anachronism. A general shortage of permanent rehearsal space in New York and other dance capitals, along with a creative economy that privileges detached and mobile

artist-dancer-choreographers, encourages this view. But there's something more to it: an interest, perhaps, in different kinds of legacies, different modes of courting the present. If repertories are becoming obsolete, what do you do with a dance when a dance is done?

Michelson has conceived of "modular" dances—whole works that can be cut-and-pasted into other dances. This is not dissimilar to the logic of Cunningham's Events, singular occasions that were organized with material spliced from repertory; and certainly dance history is littered with the magpie operations of choreographers lifting movements and phrases from themselves and others. But Michelson's tactic might be unique, in that she occasionally imports, wholesale, evening-length works of her own into another dance, creating a full-fledged hybrid that is more than the sum of its parts, as at the Kitchen in 2003, where *Grivdon at the Grivdon Concrete* was intertwined with new choreography. Significantly, the dancers themselves are rarely imported with the dances. *Grivdon*, performed by the five young girls in *Shadowmann: Part 1*, was originally danced by Michelson and her peers at the Kitchen in 2002. Another work, *Daylight (for Minneapolis)*, from 2005, is a composite of two other dances created earlier that same year: *Love Is Everything*, which was originally made for members of the Lyon Opera Ballet, and *Daylight*, which played at P.S. 122. In *Daylight (for Minneapolis)*—which inaugurated Herzog & de Meuron's William and Nadine McGuire Theater at the Walker Art Center—the Lyon dance was performed by fifty girls, boys, and young women around and beyond the quartet that forms the core of both *Daylight* and *Daylight (for Minneapolis)*.

For *Daylight* Michelson had special risers built that shrank the already small theater space at P.S. 122, exaggerating the intimacy of the dance—performed by Michelson and her gang of stars, Iveson, Lutz, and Zuccolo. When the dance was remade for Minneapolis, Michelson brought the handmade risers with her and stuck them on the McGuire Theater's main stage, where they were engulfed by the raked, stadium-style seating. "The idea," she says, "was that my 'downtown,' cheap, P.S. 122 version, built according to our interpretation of details from Herzog & de Meuron's PowerPoint presentation of their building, would go and sit inside this grand space."[13]

Michelson's peregrine downtown: there are traces of myth here. But it is in *Devotion* that Michelson's myth making is at its most expansive, at once biblical and artistic. For *Devotion* Michelson again flipped the Kitchen's stage, this time clockwise, so that the audience faces west instead of the usual south. The twist evokes *Shadowmann*, but here you look not at the entrance but at a black wall. You look anew. The first twenty-some minutes feature Rebecca Warner, as the Narrator, dancing as Michelson reads a long prose poem—a reworking of Genesis and the birth of Christ adulterated with personal reflections—written for the occasion by the playwright Richard Maxwell: "The sun and the earth are still strangers getting acquainted and learning fresh and new ideas together.

Nothing has been defined. Where will you go? What will you do? All is open. All is available. You only need to decide."

Warner walks, holds a pose, her arms out in an embrace then stretched wide, her feet torqued. Stops. Holds a different pose. The positions are strange, staccato yet fluid; they latch and unlatch, forming unfamiliar insignias. They are not "Cunningham," but they feel of him, bear marks of his elegant, stiff liquidity. Critics have noted that some of the phrasework in *Devotion* resembles that of specific Cunningham dances (*Interscape*, 2000) or even particulars of his technique class. But the quotation, if it can be called such, is not strong; it doesn't announce itself so much as it haunts, shapes, filters. Not Cunningham but Cunninghamesque, the legible trace of something we might call technique, or style.

Michelson continues to read. Twenty-five minutes on, a bright light shines from the north wall, and out of it emerges a gangly, captivating fourteen-year-old in a white tracksuit: Non Griffiths, aka Mary, or as Michelson puts it privately, "little Lucinda Childs." Soon Philip Glass's 1986 "Dance IX" strikes up, and Griffiths is joined (immaculate conception) by the gaunt James Tyson as Jesus. The eight-minute-long "Dance IX"—a direct invocation of Twyla Tharp's brilliant 1986 "crossover" ballet *In the Upper Room*, for which it was written—plays three times in succession. Warner reappears with another dancer, Nicole Mannarino; their new costumes borrow from Norma Kamali's signature black, white, and red designs for *In the Upper Room*. At moments the duet performed by the next two dancers, Jim Fletcher (Adam) and Eleanor Hullihan (Eve), recalls Tharp's choreography, though "Dance IX" has by now given way to a driven instrumental score by the composer Pete Drungle. The Adam-Eve duet is one of the most powerful and memorable dances in memory: a twenty-five-minute athletic pas de deux of sprints, jetés, stunts, entrances, and exits. Eve spends much of the time running to and from Adam across the stage, occasionally allowing him to hold, catch, or assist her. In the end, the euphonious music gone, the pair simply look at each other and—détente—together walk out the door.

There is a unique timbre to this reflexivity, to the intimations (not imitations) of Tharp. Michelson takes the costumes, the music, but hardly the phrasework—the "dance"—itself. *Devotion*'s peculiar mode of citation can't be reduced to *spolia*, to pastiche. Tharp is explicitly considered, though, intriguingly, she is mentioned nowhere in the program notes; Cunningham is felt more primally, evoked in the subterranean habits of the lived, "technical" body and in the open, exquisite solitude of Warner's solos that begin, and also end, *Devotion*. Unlike *Shadowmann* or *Daylight (for Minneapolis)*, which cannibalize Michelson's earlier work, *Devotion* mainlines other choreographers, other dances, other techniques. The references are all palpable but are held in suspension in Michelson's colloidal dance.

For whom, one wonders, is this signification, this taking? If *Shadowmann* points reflexively toward the Kitchen and P.S. 122, gesturing to the kinds of audiences these spaces engender and toward other Michelson dances, the psychic address of *Devotion* is more catholic and the history is deeper—the mythopoeic history of dance itself. The costumes and music from Tharp's *In the Upper Room* function in part as a theatrical Polari, an argot understood not just at the Kitchen and similar nodes in the downtown or European festival network but at proscenium venues that specialize in repertory, in the dance world at large. To name names in the program notes would be to betray the trajectory of the message, to give it to everyone. The devoted audience meets the devoted dancer, and at this intersection they find common ground. At the core of this shared history is the quasireligious piety of the daily practice of a technique or rehearsal. "'You must love the daily work,' he would say," Rainer wrote in 1973, reflecting on her early experience studying with Cunningham. "She [Rainer] loved him for saying that, for that was one prospect that thrilled her about dancing—the daily involvement that filled up the body and mind with an exhaustion and completion that left little room for anything else."[14]

The daily work. The Cunningham/Rainer catechism echoes in *Devotion*. Echoes but doesn't prescribe. It says: we do our daily work our own way.

It's March 2012, and the fourth floor of the Whitney Museum of American Art in New York is covered with a white Masonite surface on which has been traced a version of Marcel Breuer's floor plan for the 1966 building. *Devotion Study #1—The American Dancer* is new territory for Michelson. This is not her first dance in a museum, but it is the first to be sited in a museum gallery, curated into an exhibition format (the Whitney Biennial), to be not just proximate to the corridors of visual art but of them. Architecturally speaking, a museum gallery is not so different from a black-box space like the Kitchen, at least when compared with a proscenium, though this rectangular Whitney box is so white and bright it seems the anti-Kitchen.

Michelson has the advantage: she knows how to make a box sing. The Whitney space is configured in a way that recalls the setups for both *Daylight* (at P.S. 122) and *Devotion* (at the Kitchen), with the audience seated on risers set against the longest wall and the dancing area wider than it is deep, creating a shallow depth of field that stretches on and on to the left and right. The term *study*, cheekily subsequent to what the dance is a study "for"—presumably the 2011 *Devotion*—is both a joke on the idea of dance in the museum (how could it, particularly in the Whitney Biennial, be anything but a "study" of a dance, i.e., not the thing itself?) and a proposal: it might mean, "See? This is what devotion looks like."

Michelson stopped dancing in her own pieces after *DOGS* premiered at the Brooklyn Academy of Music's Harvey Theater in New York in 2006. Both a

riposte and a surrender to the tenets of proscenium dance, that work's peculiar, eulogistic pitch is made explicit in one indelible scene, after intermission, when the audience returns to watch two women twirl in and out of a dense cloud of fog. They look like Michelson and Jennifer Howard, both of whom dance in *DOGS*'s first half, but these fog women flit like sprites, and as the mist recedes you realize they're teenage girls—Alice Downing and Laura Weston—styled as Michelson/Howard doppelgängers. No body is spared biology's dogged caprice. Since then, the dancing has grown more elaborate, demanding, and severe. In 2009's *Dover Beach* and in *Devotion*, there is quite simply more choreography, and more unique choreography, than in any of her works prior. There are also more physical tests, as when Warner, in *Dover Beach*, balances in a sort of *attitude devant* for what seems an impossibly long time or when Fletcher and Hullihan sprint, near the end of *Devotion*, laboring until endurance forfeits to a kind of grace.

This "testing" is most pronounced in *Devotion Study #1*. It comprises a single phrase—really a continuous, legato traveling step, a variation on the backward triplet—with arms extended to the sides, the dancers' path so tightly set it is impossible to know where and how they are finding their marks, how they stay together. The triplet has its source in a phrase—much the same, but with sped-up footwork—that Tyson and Griffiths do together forty-five minutes into *Devotion*. Instead of replaying an earlier dance in full, Michelson is bracketing off a few seconds, homing in, refining the steps as if they're rocks in a tumbler, like a master urging her pupils forward with correctives: Again. Again.

Again, the dance begins with the reading of a text written for Michelson by Maxwell, this time a purported dialogue between the two, with Michelson reading her own part and Jay Sanders, a curator of the 2012 biennial and commissioner of the piece, reading Maxwell's part.

"Does your public affect you?" Sanders reads. "I'm waiting to see what you say, before I answer. Do you feel like you need to give them a way in?"

"I don't," says Michelson. "I mean, it has meaning for me."

Is it, finally, all about her? What does one make of Michelson herself—that is, of Michelson's image, which is figured so persistently throughout the dances she creates? The first such representations occur in *Daylight* and *Daylight (for Minneapolis)*, portrait paintings by Claude Wampler of Michelson, her fellow dancers, and institutional staff. At the Whitney, Michelson's face and hair are outlined in neon light on a wall; this logolike portrait, designed by Charlotte Cullinan, is familiar from *DOGS* and *Dover Beach* and will recur elsewhere. A critic writing about *Devotion Study #1* for the *New York Times* offers this startling interpretation: "The choreographer whose image looks down upon the dancers and who keeps interfering and who demands acts of devotion is a cruel and anxious god."[15]

The religious imagery accrues. *Devotion Study #1* has an enigmatic epigraph, a 1937 quote from Balanchine, also used in Jennifer Homans's controversial 2010 history of ballet, *Apollo's Angels*, to introduce a chapter on the "American Century" and the "New York Scene":

> Superficial Europeans are accustomed to say that American artists have no "soul." This is wrong. America has its own spirit—cold, crystalline, luminous, hard as light. . . . Good American dancers can express clean emotion in a manner that might almost be termed angelic. By angelic I mean the quality supposedly enjoyed by the angels, who, when they relate a tragic situation, do not themselves suffer.[16]

Does Michelson buy this? It seems hard to believe, just as it's hard to take the *Times* critic's characterization seriously. Yet, suggestively, the neon portrait is, in a way, cold, crystalline, luminous, hard as light. Who can doubt that Balanchine's Apollonian angels are in some way avatars of American industry, of capitalism moderne, sleek and beautiful and rational? Maybe Michelson's serial self-effigies are indicative of a dancer for a new century and scene—not an American century, not even a New York one, but a century that belongs less to any state than to an economic order. This dancer lives, with a special intensity and literalism, the internal split that arguably haunts every member of the precariat, every freelancer, every artist—the split between self and image, body and brand. Repetition, seriality: the lot of those individuals who market themselves, who "become brands," who are expected to give the people what they want, over and over again. Michelson's modularity flirts with this expectation and flouts it. Less songs of herself, maybe, than paeans to contemporary anxieties, the portraits may actually be—at least to those members of the audience who get the joke, and who get Michelson—*funny*, and are perhaps never funnier than when read against Balanchine's prose poetry. But while there may be humor here, and a distancing in her framing of the words, there's no evidence that she is engaging in deconstruction or critique. Nothing about *Devotion Study #1* or the earlier *Devotion* evinces irony, pastiche, or irreverence. Their greatness in part is a function of the way they give dignity to the small, inexplicable texts and gestures they set in motion.

Five intrepid dancers perform the backward triplets: Maggie Cloud, Moriah Evans, Hullihan, Mannarino, and Tyson. Mannarino is the first to enter and the last to leave, and by the end she has performed these triplets, in *relevé*, for ninety minutes. Her blue pantsuit is soaked in sweat, yet her face remains the very picture of angelic sangfroid. It is as though the sweat isn't coming from her but from you: like her clothes are wicking water from the air.

At the end there's another reading by Michelson, a fable about a second child of God, a girl named Marjorie. "Make it very beautiful," Michelson says.

It's the first weekend of November 2012, and a crowd gathers in the Donald B. and Catherine C. Marron Atrium at The Museum of Modern Art in New York. We've come for the final weekend of Some sweet day, a germinal series of dances organized by the artist Ralph Lemon and Jenny Schlenzka, a curator at MoMA. Only a few days ago, Hurricane Sandy put the whole city on pause, and it's hard to believe that anything is happening here at all.

Michelson wears a white blouse and skirt, and she beams as she walks across the broad slate expanse toward a laptop stationed at the west wall, installed between the two entrances to the second-floor contemporary-art galleries. She takes her place in the crowd, which hugs the sides of the space, leaving a vast, unpopulated square in the middle. A tinny version of Double Exposure's buoyant, aspirational 1976 song "Everyman" starts up on the loudspeakers, filling the vacuum of MoMA's hull. And then, up the stairs from the lobby, chaperoned by MoMA security guards Tyrese Kirkland and Gary Levy, bounces Mannarino, all verve and bright brio, wearing navy hot pants, white sneakers, and a blue cap-sleeved shirt. Her hair is in pom-pom pigtails. She is everything, a gorgeous, tiny hoyden, like a vintage carhop shot through the Paradise Garage on her way to MoMA. She spends much of the dance with hands clasped behind her or arms akimbo, her attention on her feet—which kick, twist, and shuffle sideways in a straitjacketed Lindy hop, never on the music but clearly in dialogue with it, tracing a path along the floor. It is awkward, this dance, full of a kind of concentrated kinetic pleasure that is never entirely expelled. Michelson selects the tunes, all galvanic, contagious soul. It's the middle of the day, and the crowds swirl around the museum, sticking to the dance like filings to a magnet, sometimes moving on after a few minutes at the pull of some other force. But more often than not, those who come, stay.

This work, *Devotion Study #3*, appears to be one of the few solos in Michelson's oeuvre. (Of a potential *Study #2*, Michelson is mysteriously mum.) Much of its drama revolves around whether Mannarino can hold the attention of the crowd in this unforgiving space. (She does, handily.) But it's not so cleanly a solo. Mannarino is actually paired with Michelson, for whom she seems to dance—like a game Albrecht for the Wilis. Michelson leans over her laptop, DJing and whooping in concert when Mannarino lets out the occasional "Aaaaaaah!"—a spontaneous, joyful scream. And there is another dancer, James Tyson, who spends much of the thirty-minute performance running through the museum—shirtless, sinewy—performing the same (or similar) offbeat sideways-swivel-kick footwork in the galleries.

Has the Marron Atrium ever felt so alive? The dance pulls in a crowd, but it also reorganizes the flow of museum traffic, as security guards hold a position on the Atrium's east side, directing visitors and splitting the main stairwell in two, keeping open at all times a clear, VIP path for Mannarino. We're in the middle of 1979's "Janice (Don't Be So Blind to Love)," by Skip Mahoney and

the Casuals, when Mannarino leaps back from the center of the Atrium and walks toward the stairs to the lobby, escorted by Kirkland and Levy. The music continues to play as the traffic-flow infrastructure folds in behind her.[17]

Michelson's works are alloyed with institutional agents and supports: years after he played King Lear to the cast of *Shadowmann*, Henry Baumgartner poured wine for Michelson and Lutz onstage in *DOGS*; at the Walker, Wampler's portraits of Philip Bither (the museum's performance curator) and Kathy Halbreich and Richard Flood (then the director and deputy director, respectively) were hung throughout the venue; Sanders read Maxwell's text at the Whitney; MoMA's security guards became glamorous escorts for Mannarino. And there are more examples: Tyson, who performed in *Devotion* (as Jesus) and in *Devotion Study #1* and *#3*, is the performance programmer who commissioned *Dover Beach* for Chapter Arts Centre in Cardiff, Wales; Mikhail Baryshnikov, who commissioned a 2002 Michelson work called *The Experts*, was also that dance's celebrity guest star. Everything and everyone is game for aestheticization. Every space—the lobby, the street, adjacent galleries—is taken. Choreography absorbs—takes on, takes in—the institution's administrative talismans. Michelson's choreographic magic is such that this integration comes off as organic *and* inexorable; it's of a piece with the piece. And with the place—the site, the network, the milieu.

We begin with habitation, a neighborhood, perhaps a place with which we connect—the Kitchen, P.S. 122. And from this might emerge a habitus, unique sensibilities, attitudes, ways of moving through something we might call technique or simply the daily work, which might live for a little while in something brief called a dance. It comes out of and becomes a way of life, reinscribing a social world or a psychic community of historical addressees. *Habitare*, "to live." Not for just anywhere, not for just anyone. But for you and me, the devoted.

Sunset in the Kingdom of Manhattan

It's 2005, and a friend takes me to P.S. 122 to see a dance by Sarah Michelson. The friend, Kim Brandt, is also a choreographer as well as a dance programmer at Dixon Place, a nimble, scrappy, second-floor SoHo loft space at Bowery and Prince Street known for giving young performing artists—everyone from Penny Arcade to Blue Man Group—a start. Brandt has cast me in several of her dance works, introducing me to the game of mingling "trained" and "untrained" bodies. She has also been my chaperone through this complex, incestuous dance world, where the lines among artists and critics and curators and performers are porous at best. Hers is a generation that takes for granted the lessons of Judson and the post-Judson and anti-Judson generations that followed, including the crucial axiom that all kinds of bodies can matter onstage.

We arrive with Ellie Covan, Dixon Place's founding director and one of Michelson's early advocates. Covan commissioned *Blister Me*, a duet Michelson

made in 2000 with the artist Julie Atlas Muz as part of a series called Mondo Cane! For that performance, water was the muse. Muz and Michelson painted the venue blue and filled the set with blue-tinted liquid props: Listerine, Windex. The audience covered their laps with a plastic tarp, a bulky prophylaxis from Muz and Michelson, who sprayed them with water from their mouths. The whole thing was like an amusement-park ride.[18]

As with *Shadowmann* before it, the visual design for *Daylight*—the show we are here to see—makes the upstairs gallery at P.S. 122 unrecognizable. Specially built risers box in the performance space, shortening the stage so that it's wide but shallow: twelve feet deep and forty feet long, an unusual letterbox ratio that will become a Michelson signature, especially in the Devotion works. The setup compromises audience sightlines; it's impossible to find a seat from which you can see the entire dance. To exaggerate this partial view, a tight band of bright PAR lights runs along the front row, directed toward the ceiling so that when they are activated a luminous fence will form between the audience and the dancers. The spare black fixtures jut and frame every angle of the pale dancing space. But the most striking aspect of the design is Wampler's four wistful, ten-foot-tall cadmium portraits depicting each of the work's principal dancers: Michelson, Lutz, Zuccolo, and Iveson. They lean casually against the back white wall, romantic, slacker elegies. Here are our heroes.

The dance begins as audience members are still making their way to their seats. At once: a band, hidden behind the audience, plays the opening chords of Gerry Rafferty's nostalgic 1978 hit "Baker Street." At once: the four dancers emerge, loping in unison from an illuminated portal built into the back wall, stage left.

Zuccolo and Iveson sport billowing, untucked button-up shirts, recalling the costume that Dominique Mercy, a dancer for the choreographer Pina Bausch, wore during the 2002 Bessies award ceremony in New York. Michelson and Lutz wear green patterned sundresses with gold necklaces and hoop earrings, their hair pulled back in high buns: statement hair, something from a vintage vision of "modern dance." The costumes are anachronistic, "gorgeous, but unidentifiable," Tere O'Connor says.[19] The dancers look like they could be in an advertisement for Zinfandel: tasteful, white, earnest—the kind of people who might want giant portraits of themselves. The kind of people who could afford them.

"This city desert makes you feel so cold / It's got so many people but it's got no soul," the singer sings. When the song ends, the saxophone strikes up again and the band—why not?—plays it a second time. The live music makes an overly familiar song strange again; the repetition adds to the interest. The dancing is more or less on the music, walking and turning, raising an arm and then kneeling—lines of flight not precious but precise—punctuated by long bouts of stillness.

After nearly fifteen minutes, the band drops out and the music snaps to a recording of The Diplomats' high-impact hip-hop song "I'm Ready," from 2003.

The movement speeds up to accommodate: more turns and circles and then pauses in which the dancers simply stop and give each other knowing, exhausted looks. Iveson kneels and puts his arms around Zuccolo, burying his head in Zuccolo's stomach as the latter gazes out at the audience. Lutz and Michelson rush by, then stop and look at the men. The lights dim. They hold for a minute—the Barbara Mason sample "I'm ready . . . I'm ready . . . " looping—until Iveson stands and the two men embrace. Some of the dozens of lights go up, and the dancers pat the air and spin and break into spastic patterns.

In the *New Yorker*, Acocella calls *Daylight* "one of the strangest things I have ever seen." I think she means this as a compliment. "Today's downtown surrealists tend to be more ambiguous [than Pilobolus and Pina Bausch]," she says. "Therefore, they are still downtown."[20] I think this is less of a compliment. Who, she seems to ask, would choose downtown nights over boreal lights?

O'Connor writes a savage, incisive riposte to Acocella, attacking her "anachronistic insistence on an uptown/downtown dichotomy" and the laziness of her "surrealist" metaphor.[21] I agree with O'Connor, though this metaphor is useful evidence of the traction of certain bitter corners and happy islands. *Surrealist* is the wrong word, but there is a related strategy that makes sense here, and that's juxtaposition, or, as Michelson prefers, "modularity."[22] This against this. "This shouldn't be here . . . but it is" is a Michelson strategy. "There's something about what's 'not allowed' that I'm attracted to," Michelson says, "whatever that might be."[23] It's possible that at the time of this dance, the "uptown/downtown dichotomy" was not yet anachronistic. But perhaps it became so on the occasion of this correspondence: the last time Acocella tried to identify a "downtown" community, the moment O'Connor *called* it anachronistic. The year the erstwhile queen of downtown moved to Brooklyn.

It may be that what is ambiguous to some is a love letter to others, or that ambiguity and strangeness are ways of claiming your integrity. For protecting the terms of your minor literature. Aside from personal charisma and movement quality, part of what makes Michelson, Lutz, Zuccolo, and Iveson so captivating in *Daylight* is the strange way they move together—not in rigid lockstep, evincing the professionalism of a trained company, but instinctively, like a pack.[24] And part of what makes the work so moving, what gives it that wistful temperament, is the sense that we're witnessing the band's last tour, a hard-won friendship in précis. So much walking, crosstown walking with a spring in their steps, back and forth across the stage. So many knowing glances. Lutz and Michelson eye each other as if to say, "We're still doing this." This is a dance of desideria and loaded looks. And this, to me, is what makes the dance both "strange" and totally familiar. The dancers' relationships are frontal. They are not addressing the audience; they are addressing each other. This is for them, their last dance. No one else could do this dance.

"*Daylight* is about us and where we're up to in the journey of making dances together," Michelson tells the *New York Times*.[25] The work is, among

many things, a romance with the band. A kind of *Gimme Shelter*. Watching it, we can imagine the scenes of their meeting, the biopic of their happy but arduous journey toward imminent dissolution. It plays to the fantasy of the itinerant, tight-knit, generationally homogenous group of struggling friends—living life and playing it back through the filter of their art. The sweat and strain is foregrounded—they dance as though they're getting through it. Their faces evince not exuberance, not neutrality; they are a vision of soldiering on.

"Where she's going . . . I have no idea," writes John Rockwell in his review for the *Times*. "Where she's at, as we said in the '60s, is pretty intense." What is this intensity, with its whiff of Boomer-era Village bohemia? "What does it all mean?" Rockwell asks. "I cannot say, even though it was meaningful to me. Maybe it's about the dancers themselves, given the large stenciled portraits of each on the walls. But that sounds trivial."[26]

It doesn't sound trivial to me.

The lights dim with the fourth and final section, accompanied by Iveson's somber, New Agey instrumental track—a doleful collage of pipe organs, horns, and Moog synthesizers. The dance laments. The lamps lined up in front of us brighten and the dancers stand before us, sweeping their hands through the bands of light in unison. One final time, they turn on a diagonal and lean forward and bring closed fists together in a small, rotating motion as they scrub their knuckles together. They've been dancing for thirty-five minutes straight, and their clothes are heavy with sweat. Then they stop. "Roger," Lutz says, in a strained, theatrical voice, holding Zuccolo's hand as they lean away from each other. The music is gone; the lights are dim. "Have you been swimming? Hello? It's fine if you have."

It is at this brief moment of insincere, literary pretension (who's Roger?), Acocella writes, that she begins "to feel a little abused." Lutz's line is a lot like one of those "irresponsible noises"—like Rainer's scream at the end of her *Three Seascapes*, of 1961—that punctuate the history of respectable dance.[27] But whereas screaming is by now a more or less acceptable expression of subjectivity in Michelson's milieu, bourgeois bathos (swimming?) is something else entirely.

Daylight ends in the dark, in silence, as the dancers exit the theater's front door, striding in the same exaggerated lope—heads swinging side to side, arms alternating up and down, all on the same jazzy rhythm—with which the piece began.

But, in fact, it doesn't end there. The houselights go up and we start to leave. Several minutes later, a guitar strums and the singer begins a plangent song. A young woman, Lindsey Fisher, wearing sweatpants and a hoodie, her long hair swinging (counterpoint to Michelson and Lutz's uptight 'dos), emerges from the stage-left portal and begins a fleet-footed, three-minute coda—the dance we've just seen, reduced to its basic movements. The dance's rebound. Here, finally, as O'Connor points out, is dance's "old trip," theme and variation.[28]

Her clothes are slacker college-student couture, but her body is honed—taut, then fluid, as her arms chisel the air. She teases the dance that came before. You can only dance like this when you're young, and we sense that Michelson, now forty-one, perhaps twice this dancer's age, months behind in rent, preparing to move from the East Village to Brooklyn, is already beginning to cast herself from her work. "Never fade away," the singer sings.

Call it her *Destruction of Lower Manhattan*.[29] "The East Villagers were the last subterraneans who actually had a terrain," Cynthia Carr writes, "because during the 1980s the whole concept of marginality changed."[30] Marginality changed in the 1980s, but the sack of the East Village was gradual, continuing through the 1990s and 2000s. *Daylight* marks a crossroads of art and life in early third-millennium New York City. It is the swan song of that physical/epistemological gentrification effected by the human losses of AIDS and policies privileging privatization and the ascent of a financial-service economy. It is Manhattan's last dance.

"Attitude sells," writes Acocella, noting that Michelson's next work will be staged at the Brooklyn Academy of Music, making her one of the few in her generation to test "the major channel by which downtown work meets uptown ticket buyers."[31] It is not Michelson's talent or generosity of vision or even her alluring "surrealist" ambiguity that begs broader attention, Acocella seems to be saying, but her "attitude," specifically the small ruptures in her dance—the bit of opaque, bourgeois-sounding theater, the trick ending and coda. The places where she puts pressure on audience expectation—the idea that her work will "look" like downtown or modern dance, or that it will deliver a sanguine ending. Those places, in other words, where she irritates, simultaneously con-summating and dispelling ideas of what our community is, of who her viewers are, of what we think we want. "Attitude sells," Acocella says, invoking simultaneously an oppositional disposition and that elemental Blasis pose. Sell it does—but, as we will see, it also becomes form.

<div style="text-align:center">

4

</div>

It is amazing that in spite of the great emotional involvement that seems to motivate most of [Balanchine's] works, it has often been pointed out that they are coldly clinical, athletic, and mechanical.

—Walter Sorell, "Notes on George Balanchine," 1970

4 is more than just another dance at the Whitney. It is Michelson's first work staged as a solo exhibition at a museum and also, perhaps, the first theatrical dance work commissioned as a stand-alone exhibition *in* exhibition space since members of the Judson generation were brought in by the Whitney in the early 1970s (Rainer's *Continuous Project–Altered Daily*, Trisha Brown's Equipment Pieces, Lucinda Childs's *Untitled Trio*). Mounted in 2014, *4*

consummates a trajectory for Michelson but also for choreographers everywhere, as dance becomes more and more imbricated with the institutional repertoire of visual art.[32]

Not simply a "study," *4* is a commitment to the museum as site. Its title is a rebus: *4* is the fourth dance in the Devotion series, and it also plays out on the Whitney's fourth floor (as did *Devotion Study #1*, two years earlier). Like *Daylight*, it features four principal dancers: three women—Rachel Berman, Nicole Mannarino, and Madeline Wilcox—and one man, John Hoobyar.

An elevator brings you up. As you arrive, you notice that, again, the direction of the stage has been flipped: this time the audience faces the elevators. You walk across a Masonite surface, which Michelson and her curator, Jay Sanders, have painted in dense, AbEx globs, the colors approximating the earthy palette of the bluestone tiles underneath. There are three banks of poufs, each imprinted with a Northern Soul logo reading IT'LL NEVER BE OVER FOR ME. A pair of black leather shoes are nailed, toes down, next to the elevators. A large scoreboard, lit with five neon-green zeros, hangs from the back wall, stage right. There is no "offstage."

You sit. Michelson and Sanders take their places on seats amid the audience, stage left, in front of a pair of microphones and a laptop. The dancers emerge from the south galleries and stand before the aisles dividing the seats. They wear blue hoodies with cushioning built into the elbows and neck, and also unitards and leotards and sweatpants—all practice clothes. As in *Devotion Study #1*, Sanders and Michelson read a Richard Maxwell text into a microphone. "This is the third and final *Devotion*. There was a fourth, at The Museum of Modern Art . . . "

The text is long and frequently loops back, repeating itself: sometimes illuminating, sometimes obnoxious conversation on dance, modernism, Walter Benjamin and Gershom Scholem, Proust, Nijinska. As they talk, the dancers begin to rise and fall on the balls of their feet, taking little warm-up jumps in place. And then: slow somersaults.

Michelson shouts out numbers. The scoreboard responds.

Is this a dance? A game?

At what point do you realize that the dancers are being scored? At what point do you realize that it's the dancers themselves who are doing the scoring?

As in *Daylight*, the four dancers are all of the same generation. But there is no intrinsic differentiation among them. Not even a hierarchy. At least not in the beginning. The emphasis on a charismatic "star system" from earlier work (think *Daylight*'s and *Devotion*'s portraits of luminaries) is, in *4*, submerged. Everyone begins the same.

The black box and the white cube are oh so different, but they do share one important feature: a lack of illusionism. There are no "wings." To exaggerate

this, rather than seal off the performance environment, Michelson allows the museum's elevator doors to open directly onto the floor, which they do sporadically throughout the performance, encouraging frequent awkward interruptions as museumgoers find themselves face to face with an audience staring back at them. (What is the performance like from their angle, as the doors open . . . then close . . . on dancers aboard a vast, painted arena?)

À la *Devotion Study #3*, the music is nostalgic soul from the 1960s and '70s: Betty Wright's "Girls Can't Do What the Guys Do" and Four Below Zero's "My Baby's Got ESP." Michelson plays it through her iPhone's native speakers directly into her microphone, which broadcasts the tinny noise into the space. It's slow going, this dance. Music. Silence. Sideways swivel steps. Jumps and somersaults.

"A friend rightly said after Friday's show, 'Those somersaults were the most precise I've ever seen.' It's that kind of show," Macaulay writes in his review for the *New York Times*. "She seems stuck in the rut of the 'Terpsichore in Sneakers' dance makers who emerged in the 1960s, sharing their concentration on pedestrian vocabulary and repetition."[33] Macaulay is going for the kill. Bourgeois condescension and a winking knowingness is his critical tool. Another review, by Claudia La Rocco: "Olympics," she says, listing off her impressions. "American athleticism. Futility."[34] How could these two critical impressions be so wildly different?

Dance of the past century's American modern and postmodern canon— maybe longer—has been circumscribed by the so-called pedestrian gesture: those movements we do every day, uninflected with the apperceptive knowingness of "theatricality." While taken for dance by figures as various as Balanchine, Cunningham, Yvonne Rainer, and Steve Paxton, it is not in and of itself dance; it requires a theatrical container. Some of the most iconic dances by protagonists of the early Judson concerts—most notably Rainer's *We Shall Run*, of 1963, and Paxton's 1967 *Satisfyin Lover* and 1968 *State*, which featured, respectively, running, walking, and stillness as subjects—approximated the pedestrian while still preserving the isolating conventions and frames of dance: a title, a time and place, and an audience pointed in a certain direction. A choreography. Thus, even as it assimilated the pedestrian, modern dance has also always excluded it, and in the experiments at Judson in the 1960s it was toward that exclusion that dance bent.[35]

As the rhetoric around Judson's historicization has made clear, the tendency has been away from a regime of virtuosity and toward equality, or a noncompetitive integration of various kinds of bodies.[36] But in granting the existence of pedestrian movement, we also accept the existence of a body not already inscribed with the habits of culture. A "natural" body, as if any body that stands and walks could be lacking technique. This pedestrian body, an "untrained" body, is occasionally conscripted for a dance, though often to present a limit—to frame the "cultured," dancing body and allow it to flourish. The pedestrian is the logical frame of modernist dance vocabulary, limning the edge between outside and inside, a frame

constantly tested by choreographers set on unsettling dance's proscriptions. This expansion, while opening up the field of who might be considered a dancer and what might be called a dance, continues to insist on an essential difference between dance and nondance. Dancer and audience are produced via the occasion of this difference. But pedestrian movement is also the place where the dancer and the everyman audience member intersect, where the latter is—to risk the baggage of an old Althusserian term—interpellated, where she can recognize herself onstage. In the supposed pedestrian gesture, the viewer might see herself reflected.

Macaulay's fixing of *4*'s "most precise" somersaults as part of a legacy of "pedestrian" movements—a legacy he marks as Judson's—gets at something important, though it starts on the wrong foot. *4* is not rehearsing or even revisiting the pedestrian vocabulary of Judson, in part because such a vocabulary has never entirely *belonged* to Judson. This is not to deny Judson a role in Michelson's lineage—and indeed, her path, especially with regard to certain irruptions of the frame, follows firmly in the wake of Judson pioneers like Trisha Brown as well as contemporaneous experimenters like Twyla Tharp—but instead to expand the point of reference, and thus the dance's historical address-ees: it is Brown but also Graham, Tharp but also Balanchine.[37]

The perfect somersaults in *4* evoke the backward triplets of *Devotion Study #1*, another hieratic method of traveling across space that is not "pedestrian," that is, in other words, specific to a disciplined movement vocabulary. The movement structure of *Devotion Study #1* might recall Lucinda Childs, but the title invokes and quotes Balanchine. And in *4*: the use of practice clothes, the fetishism of American athleticism. Aren't we as much in the land of Mr. B as we are in the domain of *Terpsichore in Sneakers*?

Balanchine's contributions to the development of modernism in dance are well known,[38] but one of his most extraordinary alterations was to the *kind* of dancer ballet celebrated. "[Balanchine] preserved the [European] style, but gave it a new accent, a playfulness, a dash and daring that rehabilitated old manners into new freshness," Lincoln Kirstein, cofounder of the New York City Ballet, wrote in 1970. "American gymnasia, high-school rallies, and track meets were based on a lean-muscled and economical virtuosity that heretofore, in theater, had been the common property of Broadway and Hollywood. . . . The pathos and suavity of the dying swan, the purity and regal hauteur of the elder ballerina, were to be replaced by a raciness, an alert celerity which claimed as its own the gaiety of sport and the skill of the champion athlete."[39]

Balanchine's uniquely American, modernist form of classicism comprised a kind of *ancien régime* ballet technique modified by the spirit and "alert celerity" of American athleticism.[40] This inflection of the European with the American, as well as his repeated (if sometimes pretended) eschewal of the star dancer, was a step toward a certain kind of democratization in dance. It didn't *look* like the kind articulated by Judson, but it was not incompatible with its horizons.[41]

Against the pedestrian, then, we might consider a second kind of "non-dance" movement, the *sportif*: those kinds of physical activities unique to the gymnasium, play, and physical education. Not all choreographers of the 1930s—when Balanchine was beginning to work on articulating a uniquely American dancer—were so enamored with athletes and their habitat. The work of the "historic" modernists, as Don McDonagh terms the modern dance pioneers of the 1930s—Graham, Doris Humphrey, Charles Weidman, Hanya Holm, Katherine Dunham—in his 1970 book *The Rise and Fall and Rise of Modern Dance*, sought to "escape the gymnasium setting in which it had been forced to appear," a setting which, they worried, "redolent with the atmosphere of physical culture," compromised their aesthetic inventions.[42] Graham and Humphrey aspired to "high art" and the proscenium, and they eventually achieved it. But in the days before they developed the institutional infrastructure equipped for their particular données, they relied for financial support on a system of university tours and physical education instruction and performances in gymnasiums.[43]

Is it possible that the field of modern dance as it developed and flourished in the United States is inscribed with a deep structural and psychological ambivalence toward, on the one hand, pedestrian movement and, on the other, the athletic habits developed in physical education departments? That indeed the difference between the pedestrian and *sportif* movements taken up variously by Balanchine, Cunningham, Rainer, Paxton, et al. is only one of style and degree, not kind? Michelson has imported not the proscenium or the black box into the museum, but rather modern dance's *other* space: the gymnasium. With *4* she stages a confrontation between the pedestrian and the *sportif* through the figure of the American athlete, specifically the gymnast, and indeed through that elemental gymnastic movement: the "most precise" somersault.[44]

What makes these somersaults dance? An athletic somersault is precise; a dancerly somersault is also precise. Michelson's somersaults—head and limbs tucked in, one continuous roll, the dancers leaning into the turns—don't resemble those of a gymnast; they're invested with choreography, framed in Michelson-space, executed according to her terms, testifying to the willfully cultivated authorship of the choreographer. "What is a dance?" Michelson asks again and again in interviews. Each time it is like Icarus flying closer to the sun. The somersaults testify and reinforce the very idea of the choreographer, of the modernist individual. Because if they fail, they become "mere" athletics, falling from aesthetics, like a scene in a modernist parable.

Later I discover, through that crucial vehicle for dance-world knowledge—gossip—that these somersaults are in fact a mode of communication, the way the dancers signal to Michelson their evaluations of one another. The complex argot of the movement is a method of (democratically?) electing the winner at the end of the dance.

In the kinds of structural decisions deputized to the dancers and in how far it strays from the familiar dramas and rhythms of dance theater, *4* is unlike any other Michelson work. And yet, like every Michelson work, it is impossible to see it and not think of those dances that preceded it. Michelson's works can be considered in isolation, but they reward viewings that take into account their relationship to a larger whole. Her idiom, particularly as it expands in the Devotion series, refers backward *and* forward, anticipating the next development in the chain.[45] The referential elements scatter its totalizing impulses: it is not hermetic.

But it is specific. "I have an audience of like four people, truly, in my heart, and I'm one of them," Michelson tells the choreographer Ralph Lemon.[46] "And my work is for those three people and me. Of course it's dependent on people coming to the theater; I don't have an arrogant stance in relation to that. But on the other hand, when I'm making the *gaze* of it, the experience of it is not directed for the masses. It's really directed toward a certain kind of dance lover, someone who's watching—really watching, and watching in context, and watching completely."[47]

Four dancers. And the work is for four. Is there room for an audience here?

In a dance series called Devotion, who gets to be devoted? There are the dancers and then there are those who come to the dances, who see themselves in or at least apprehend the jokes and gimmicks and references. This is dance's other addressee—not the pedestrian, "everyday" audience who might feel the remarkable *difference* in accomplished bodies performing stylized movements or who for a moment glimpses itself in the more or less mundane activities executed by the bodies onstage, but the audience who is summoned, invoked, *like* the dancer, committed to sustaining this convocation. A community of addressees, marked not by proximity or technique but by devotion—to the daily work, to a legacy of dancing, to one another.

Not *like* the dancer in terms of training; virtuosity has a role in Michelson's system—one option among many, and an attractive one—but it is not a stable end point. The logic of the balletomane is one of absolute difference: a celebration of the things I am *not*. The logic of the "democratic" dances that made up some of the activities in and around Judson Dance Theater bends toward similitude: that body *resembles* mine; I could do that. Michelson honors differences, testing bodies with her exacting dance systems, but her logic of virtuosity is one of immanence: it is unique to the piece.

Near the end of *4*, "Dance IX" plays loudly over the speakers. The only set music in the work, it announces the denouement. While Michelson's first use of "Dance IX," in 2011's *Devotion*, referenced Tharp's *In the Upper Room*, its use here points back to *Devotion* itself, and, as such, it becomes a cipher for Michelson's own self-mythologizing. "Dance IX" is, like the neon outlines

of her face and hair, part of an inside iconography, a hypotactic mess of signs addressed to devotees of her work, to the four.

One more thing from Macaulay's review, unique in its peculiar carelessness. It seems an act of acute repression that such a scrupulous observer would neglect to mention the massive scoreboard, stage right, that is so clearly essential to the work. Or the fact that Michelson is counting out numbers and that there is no apparent correspondence between the numbers she speaks into the microphone and the numbers that appear on the board. Or that there is a clear winner, a dancer who is modestly celebrated at the end of this strange, ninety-minute performance.

Through the scoring, a hierarchy emerges among the dancers, though it is not fixed: the winner changes every day. There is, however, at least one consistent hierarchy in *4*, and that is among the audience. The seats in the front row offer a more or less reasonable view of the action. From one side or the other it might be difficult to see what is happening on the opposite section of the stage, but there is always something to look at, and the compromised sightlines are a way of at once framing that action and problematizing the idea of the frame. The minor occlusion of sight stimulates the act of looking. In the second and third rows, however, sightlines are almost totally eclipsed, and for many in the audience it is impossible to see the dance at all. Here, looking is less fragmented than frustrated. Since established critics and friends nearly always have reserved seats in the front row, this hierarchy isn't remarked upon in the press; but for those in the back, the alienation is palpable. *Not for everyone.*

At the end of *4*, the dancers join in a group hug and walk offstage together. A man wearing a horse-head mask emerges and sits in the middle of the space, and a plinth appears, stacked with programs. In the notes you read that *4* is dedicated to the memories of the artist Ellen Cantor and the security guard Cecil Weekes, a black man who worked at the Whitney for thirty-three years. His mother had been a security guard before him. It is his shoes nailed to the wall.

When Attitude Becomes Form

Why are they so hell bent on just being themselves!
—Anonymous Judson critic, 1962

Spectacle is the biggest lie. It is the lie of lies, all that talk that there is a totality of seeing called spectacle, that if only we could see through the spectacle we might have respectable truth. "*No to spectacle*," Rainer began a manifesto written in the heat of 1965, two years before spectacle talk began to peak with Guy Debord's *Society of . . .* [48] It never stopped peaking, and even after Rainer herself said goodbye to her grocery list of "Noes" people continued to take the "No" as programmatic. The biggest spectacle might be the long, repetitive discourse on spectacle, which speaks only in broad sweeps and proselytizes a religion of bad faith.

So why go on about it? I promised earlier that I would have something to say about another way of looking. One way of thinking looking, a very dominant way, has it that looking is dominant, and that when we are looking everything else comes second. This is the gentrification of the sensible. We hear that to look is to stop thinking or, even worse, to *only* think—to "contemplate," as Debord so contemptuously puts it.[49] To look, we are told, is to be *apart* from what we are looking at—to somehow fail at the togetherness or sameness that is equated with such virtues as community and equality and public space.

To look is to accept representation for the thing represented. Debord is skeptical of looking partly because of what he sees as an intrinsic problem with sight. Sight is the realm of illusions, the easiest sense to fool.[50] Sight is, in this sense, also the way in which the commodity works its insidious magic most meticulously, because we are, by nature, terrible judges of appearance. "Separation is the alpha and the omega of spectacle" goes the oft-quoted beginning to Debord's Thesis 25, and it is here, as Jacques Rancière usefully points out in his illuminating 2009 book *The Emancipated Spectator*, that we can find the common logic linking the major critiques of and solutions to the evils of spectacle: from Debord to Bertolt Brecht to Antonin Artaud, different as they may be in scope and subject and methodology.

Separation kills: in Debord's reading, it begins with the spectator's alienation from modes of production in industrial and technocratic capitalism. For Artaud and Brecht, it manifests in the separation between the audience and the stage. Artaud's solution, according to Rancière, is to mystify and intoxicate the audience so that the two unite. Brecht's is to foreground and thematize this alienation so as to radicalize and enlighten the audience. Each tactic presumes the stultifying superiority of the art producer: his or her goal is to instruct the audience, to wake it up, and in so doing to abolish the constitutive separation between the theater and its audience. Rancière's response is, somewhat bluntly, to set aside these broken binaries (active vs. passive, etc.) and to elevate the multitude of individual lookers' interpretations: we all go to see art, and our own stories of the work, inflected with the experiences unique to our own lives, will go on to have meaningful lives of their own—lives, it seems, that equal or complement the beautiful lies onstage.

This is a poignant response in general. It's hard to argue with a way of thinking that restores some dignity to the audience. But its valorization of interpretation, so generous to the individual, leaves us missing Brecht's and Artaud's flamboyant specificity. Rancière does not tell us much about how to consider particular artists or works or value a specific artist's vision. Do all works and all responses to them matter equally?

"The work is only important because of a relationship to its viewership, and to the discursive relationship that you have with who matters to you," Michelson tells a room of insiders drinking, late on a summer Monday, in a small

office at The Museum of Modern Art.[51] If her super-specific spectacles can't be commodified—easily traded, sold, made "profitable"—then their worth emerges from their place in a super-specific web of people. It's not for just anyone, but for those who matter: the devoted.

This economy of devotion was at least partly forged in the amniotic confines of the downtown/East Village dance autarky. Michelson named this idea around the time that she exited Manhattan and began to move herself from the stage to the audience and to connect with and make work for people who were not her peers. Around the time that her audiences became less and less a small pack of friends and performers, when "the four" became something more abstract, passed along to history. I don't think this devotion is necessarily a devotion of the few; the four are not actually four. Nor do I think that it applies only to her and her work. "Devotion" names a condition of possibility that belongs to all of dance, to art, to a mode of viewership and its reception. A condition outside of the simple scission of actions and consequences and interpretations.

Devotion is a way of calibrating and honing looking. "Dance is hard to see," goes a favorite Rainer axiom, a seeing problem brilliantly examined by Douglas Crimp in his work on Merce Cunningham[52] and by Carol Lambert-Beatty in her work on Rainer.[53] Proscenium choreography frames the dance so that the audience knows precisely where it should be looking. But more and more, audiences accustomed to seeing dance in the traditions of Cunningham and Judson are not surprised to see dances where the viewer has to *decide* what to look at, a decision making that, as Crimp points out, "implicitly challenged the coherence of the spectator."[54]

Seeing dance is hard, until it's not. And then it must be made hard again. Crimp quotes Cunningham: "'When we first did the Events in New York,' Cunningham remembered, 'they were difficult for people to see. In the Brooklyn Academy [of Music] there was a great difficulty with the audience— the public just walked out and made a big uproar.'" Crimp continues: "That was a long time ago. Now the Events are one of the ways we expect to see—and are delighted to see—the Merce Cunningham Dance Company. Is it our eagerness to follow him wherever he leads us that keeps Cunningham upping the ante?"[55]

"I think that undoing the expectations of your own theatrical community is important," Michelson says.

For whom is Michelson upping the ante? In *Daylight* she plays with so many seeing problems: dance appears both "after" the piece is done and, in the case of *Daylight (for Minneapolis)*, behind the audience and in hidden corridors.[56] Sometimes you are able to see these tests of seeing and sometimes you don't see them at all and they become gossip, tests of knowing. (A dancer dances in a hallway well outside the performance area during 2001's *Group Experience*—or so I hear.) In *Dover Beach* at the Kitchen, this seeing problem is concretized by

a massive ornate cage bisecting the stage, so that half the dance is obstructed. There's *Devotion*'s use of the wide, horizontal staging that strains conventional sightlines. There is the second dancer (James Tyson) who runs through MoMA's galleries in *Devotion #3*, so that you must chase after him to see his dance. There is the arrangement of the seating and the serendipitous accidents with the Whitney's elevators in *4*. It is such seeing (and hearing) problems that make Acocella feel "a little abused." Abuse that she writes off as an attitude problem, but which someone else might call upping the ante.

You might say that *attitude* is just another permutation of *form*. That our sensibilities and how we live in the world and who we live for and the tools and frames and trajectories exist on a continuous plane. In naming devotion, Michelson is choosing different audiences, different terms (the artist's singular prerogative: her terms). Anyone *can* be devoted, but of course not everyone is. Certainly the dancers are devoted, giving themselves over to the obscure alchemies of technique and the difficult exercise of performing; certainly the choreographer is devoted, giving her life and time to the making of these dances. And we—the audience, the writer, the reader—might be devoted, of the four.

"I was curious about representation," Michelson says about *Dover Beach*, "the bourgeoisie, that kind of classical art, and what it means to modernity and experimentation. What is experimentation and what is the representation of experimentation on the stage?"[57] What were the Dolce & Gabbana outfits, the white limousine at the end of *Shadowmann: Part 1*, if not a kind of apotropaic glamour, estranged invocations of "uptown" and the gentrification of the East Village?[58] What were the tasteful, anachronistic dresses and jewelry—"Cesaria Evora goes to Macy's to have lunch with Lucille Ball and Edith Head," O'Connor puts it—in *Daylight*?[59] The mannered portraiture in *Daylight* and in *Devotion* and its studies? The recension of *In the Upper Room*, that incandescent dance by Twyla Tharp, herself an avatar of downtown/uptown crossovers? The cannibalization of ballet themes and vocabularies in *Dover Beach*, as well as its George Stubbs-ish painting and hunting gear and "country-home"–style back wall?

"Take away the limousine, and you get middle-class hunting scenes," Michelson says, bridging the developments between *Shadowmann: Part 1* and *Dover Beach* at the Kitchen.[60] Middle-class hunting scenes and then middle-class museums. If *DOGS* is Michelson's first and last "Brooklyn" dance, and *Dover Beach*, built in a little ballet class in Wales and then made again for the Kitchen, is Michelson's staging of provincial Britishness and class futility—of "little girls throwing themselves against this archetype in the middle of nowhere, for nobody"[61]—then *Devotion* is a paean to New York, to a new, alien New York.

Consider the disinherited New York dance world that Michelson inherited. A dance world, according to nearly every critic once in its thrall, in crisis. Balanchine, the city's crown jewel, died in 1983. This alone has been, for certain canon defenders, a catastrophe, a signal event in the decline of dance.

"In the years following Balanchine's death his angels fell, one by one, from their heights," begins Jennifer Homans's cranky epilogue, "The Masters Are Dead and Gone," in her ballet history *Apollo's Angels*. "Classical ballet, which had achieved so much in the course of the twentieth century, entered a slow decline."[62]

But Balanchine didn't just die in the middle of no-time; his death coincided with a plague that wiped out a generation of performers and, perhaps just as importantly, a generation of connoisseurs. "Everyone talks about the effect that AIDS had on the culture—ok, people don't talk about it *anymore*—but when they did they talked about what artists were lost," says Fran Lebowitz.

> But they never talked about this audience that was lost. When people talk about why New York City Ballet was so great—well, it was because of Balanchine and Jerry Robbins and people like that—but it was also their audience was so . . . I can't even think of the word. A very discerning audience, an audience with a high level of connoisseurship, is as important to the culture as artists. It's exactly as important. Now, we don't have anything like that audience.[63]

I can think of a good word to describe that kind of audience, an audience for which art matters and that matters so much to art. What does it mean to lose a part of it? How might the art itself be affected?

Between January 15, 1981, and August 16, 2008, 81,542 people died of AIDS in New York City. Michelson moved to the East Village in 1991, in the middle ages of the plague.[64] The East Village "scene" might have been "over" for any variety of reasons—depending on your witness—by the mid-1980s or the end of the 1980s or the early 1990s, another relic of AIDS and too much money and too many drugs and, most importantly, "deliberate policies, tax credits, policing strategies, and moratoriums on low-income housing," as Sarah Schulman succinctly puts it.[65] Gentrification got it good. And yet somehow that little .46 square miles on the east side of Manhattan below Fourteenth Street continued throughout the 1990s and into the early 2000s to incubate new generations of performance makers, mostly women.

Here is a story told too quickly: Michelson arrives in New York and lives through the shock/aftershock of AIDS and gentrification and a slow strangulation of public funding for the arts, the loss of an audience of performers and connoisseurs and interlocutors. She starts making work for a few people, for "the four"—herself and her friends and maybe a few others. Perhaps we have a right to think, "Well fuck her for making work for just four people. Who does she think she is?" But after the genocide of peers and lovers and enemies and admirers, making work for a small group might be a kind of protest, a way of keeping your standards when many of the standard bearers have disappeared.

Four is not two or three. It is not a couple or a trio. It is not elemental love or the primordial face-to-face that founds ethics. It is neither jealousy nor justice. It is none of those general modes of relating we project onto the young numbers and from which we have constructed our great Western epistemologies. Four is where philosophy loses count.

When it is *for the four* there is a separation among the separated—a secret amid the audience—and it is this extra separation that makes all the other splits endurable. The logic of devotion functions not along the corridors dividing spectacle and spectator but among a group of those who care, distinct from those who don't. Only when the dance is for *everyone* is it spectacle in the insidious sense: mere entertainment or, worse, pedagogy. But when you make it *just* for four, for your "little theatrical community," yourself included, the work becomes an invitation.

You might say that this idea of devotion is a new essentialism. Rancière is rightly critical of frameworks, like Brecht's and Artaud's, that privilege theater as the site of a Romantic "living community." "Theatre accuses itself of rendering spectators passive and thereby betraying its essence as community action," he writes. "It consequently assigns itself the mission of reversing its effects and expiating its sins by restoring to spectators ownership of their consciousness and their activity. . . . Theatre is presented as a mediation striving for its own abolition."[66]

But the devoted community is not a suicidal one. Suicide comes with the pathos of democracy and pedestrianism, which want to involve everyone. Recall those somersaults from *4*. The somersault is *like* the pedestrian; it seems *of* us, the unskilled audience. But it is its specificity, its stylization, that keeps it separate, and this stylization, which we seek to know, is the *self-selecting* work of devotion. "Like do you even deserve to look at this dance?" the artist Claude Wampler asks.[67] Devotion constitutes less a living community than a continual test and site of entrance.

"That is the crucial transition, from seeing to entering," writes the lodestar Jill Johnston in a 1961 review of Cunningham's *Aeon*. "Not only crucial but mysterious, so I won't say any more except to note that I think most people who go to dance concerts don't see very well, not even dancers, sometimes dancers especially, and most often the critics, who must attend special classes in becoming blind."[68]

Those special classes are audited by dancers and by scribblers of all kinds. Everyone has problems with seeing (this is one of the great joys of seeing) and, even more crucially, with entering—that tricky passage that divides the difficult activity of seeing with the difficult activity of . . . something else, something like Artaud's intoxication that unites spectator and spectated, but different. Different because the responsibility doesn't lie simply with the one who makes or with the one who sees. Because the spectator and spectated aren't so different to begin with. Our specialized differences converge at the same place: the work at hand.

We do it our own way. Doing it our own way takes attitude. What would it look like to replace a discourse of the spectator with an acoustics of devotion? Devotion not as slavish acceptance of what is done or made or seen but as an attitude problem, an anarchic erotics of art. For the four: not for just anyone, but for us, a group amid the groups (I'll try not to say community), addicted to the pain and pleasure of these intellectual adventures after the twentieth-century habits and institutions have passed us by.

In 2005 a friend took me to P.S. 122 to see a dance by Sarah Michelson. Ten years later, I sit writing about this friend and that work and then all those subsequent wild, singular, stylish, alloyed dances.

After all those dances, I would go out dancing in New York. On the dance floor I reminded myself that those dances, stuck in my head, aren't just in my head; they live for the city, for a city split and split again and for the people who come here to spit their own image and see and be seen. This condition might be called devotion or it might just be called downtown or some other sticky word for a good, strong being-together around this art we dumbly call spectacle, our way of sticking together because of that stuff that's stuck in our heads. "The illness of the gaze in thrall to shades," Rancière, channeling Plato, calls the sickness of spectacle.[69]

To which I say, If there's a cure for this, I don't want it. Their emancipation is my alienation. I want something harder. Something like Rainer's "daily involvement that exhausts and completes and leaves little room for anything else." Not no room. A little room. This little room might be the scene of what we could, some sweet day, trickily call modern dance.

Doubts as you drive down I-94e. You're on your way to the Minneapolis–Saint Paul International Airport when a text message snaps across the map on your iPhone screen. A friend, from elsewhere, taunting. Have you really seen the piece? Do you understand it? Are you devoted? Devoted enough?

It's early Saturday morning. Now you're through security, heading to the gate for a plane back to New York. The plane is boarding.

But more doubts. "I think it will be different, the final night," a dancer had suggested. Maybe you're being dramatic. Still: you open your laptop and search for flights for Monday.

It's done. You're going through security the wrong way, then boarding a shuttle back to Hertz to pick up your second rental car of the weekend. You get a text from the artist Yve Laris Cohen, who is landing at the airport, and the coincidence feels like a good sign. You pick him up curbside and together head toward the Walker Art Center. It's only noon and the sun is high and you're both delirious, ready for art's wildness.

Already you have spent ten hours watching Sarah Michelson's *tournamento*. You're not sure that it's a dance, though there's certainly dancing. There certainly are dancers, dancing like you've never seen before. There is phrasework, choreography, costumes, lighting, music, a theater. But the structure is not what you would call choreographic. It is not improvisation. It's as much a dance as a dance competition is a dance. As *So You Think You Can Dance* is a dance. (Do you think you can dance?)

Here's how it goes.

THURSDAY, SEPTEMBER 24, 2015. GAMES 1–5

Day one. At 4 p.m. the Walker's William and Nadine McGuire Theater opens to the public. The audience can sit in the main theater seats for free, or for $1 people can move to the front few rows or to five risers on the stage, closer to the action. A joke, maybe, on levels of commitment and privilege; the smallest gesture toward a class divide. Michelson sits amid the audience in front of a gold microphone and several open MacBooks. Onstage is a table with three judges: Madeline Wilcox, beautiful with hair up, heels, and a black pencil skirt; James Tyson, pale and lanky; and Danielle Goldman, dance scholar, author of 2010's *I Want To Be Ready: Improvised Dance as a Practice of Freedom*.

There are numbers everywhere. Scoreboards with numbers in red, green, blue, and yellow. Scorecards stage right, near an elevated platform, and carried around by high school girls and sitting on the table.

There are four principal dancers, each representing his or her state of origin, each with a team color. Nicole Mannarino wears yellow and is called "Ohio"; Rachel Berman wears red and is called "Hawaii"; the angular, confident Jennifer Lafferty wears blue and is called "Southern California"; John Hoobyar, intense and chiseled, wears green and is called "Oregon." You are from Oregon, and you cheer whenever he runs onto the stage.

The dancers begin by standing in the aisles of the theater's risers, each flanked by two young minders/cheerleaders, dressed in team colors, who watch them with complete focus, moving from side to side in anticipation. When the dancers achieve the stage, they scream their team names (Berman: "Hawaii!" followed by an echo, "Hawaii," from her minders). Michelson, wearing a black jumpsuit printed with a Venn diagram (Life | Dance | Death) designed by the New York–based Bureau for the Future of Choreography, regularly interrupts and encourages the proceedings: "Let's *plaaaaaaay!*" she growl/screams into her microphone. Throughout, an ambient loop of the first few laid-back chords of Kool & The Gang's "Too Hot." Or silence. Or occasionally a full song (the Bee-Gees's "How Deep Is Your Love"). Where Tamla Soul vivified *Devotion Study #3* and *4*, here it's popular R&B and disco. Donna Summer. The Emotions. The Miracles.

Six screens above the stage show grainy "rehearsal" footage of the dancers, interrupted occasionally by a 1984 photo of Michelson looking hot and cool on the coast of Greece. At least seven girls with clipboards hover around the space, doing who knows what.

"2LPF," Hoobyar yells. "2LPG. Capture."

The air is filled with letters and numbers, the call and response of the dancers and the judges. You jot down codes and phrases in the red Rollbahn notebook you bought at the Walker gift shop. Each dancer seems to have a distinct set of movements. Lafferty/SoCal falls into a sort of side-plank pose then pulls herself up in jagged spurts. Mannarino/Ohio does the sideways swivel steps from *Devotion Study #3*, yelling out "R6 . . . L6." Hoobyar/Oregon jumps into the air or stands with his hands on his hips, spinning, until he comes slower . . . slower . . . to a halt.

You don't know where to look: the "dance" has no focal point. Not in a Cunninghamesque break-the-point-of-view kind of way, which still insists on a focus on the dancing. The focus here is the system, which to an outsider (you) is all noise. *Push through the noise*, you think. *Pay attention.* But you can only attend to your lack of attention. Distractions are everywhere, organized only by a sense—sometimes delightful, sometimes infuriating—of a secret you'll never learn. The codes.

4 p.m. again. The house is open, but so far it's only you and a few others. You draw a connection with Yvonne Rainer. Bad idea, you think. A trap. But Rainer has become the go-to for art people interested in dance, and you think of her short 1964 dance *Trio A*, her insistence that the dancer avert her gaze from the audience. Because of this, *Trio A* is a signal dance in analyzing how a dancer *presents* to an audience. The dancer looks everywhere and moves in every direction, but connection with the audience is deprioritized. There is no illusion of access to the dancer's interiority.

The dancers of *tournamento* are the end point of this presentational tradition, which some would call postmodernism. They don't dance for the audience, not at all. They appear inward focused—like athletes. The dancers are performing for themselves, for the judges, for one another, but not for you. You have never felt more irrelevant. Or more absorbed.

So you sit and walk around and take notes, knowing that nothing you do can influence the direction of the game. We're through with *Devotion*'s entanglements. This isn't history dance—at least not in a palpable sense. The Rainer metaphor is your own invention; any invocations of other choreographers ("Cunninghamesque" movements or references to Childs or to Tharp's *In the Upper Room*) are gone. This is the evolution of Michelson's "modularity": it was whole dances engorging each other, like matryoshka dolls, then it was a single phrase (*Devotion Study #1*) stretched to absurdity. Now the dancers each have their own set of phrases (called "components" or "elements"), uniquely Michelsonesque, which they do over and over. It is a drift tube of Michelson moves.

The dancers perform these steps according to obscure but brutally observed rules. You want to know how they're being scored. The trick, you learn from listening to the conversations between Michelson and the judges and the dancers, is to be "clear" and "fresh." To not "strategize" (strategizing is "bad"). To not "pattern."

The day began with Game Six; the day before, after five hours, ended with Game Five. It just keeps going. There is no difference; or everything is difference. You wonder (and there is so much *time* to wonder): What happens when the stakes aren't related to the virtuosity of execution—about the clarity of the plot, recovery, and climax of the gesture? If the judges are proxy critics, what is the role of the "critic" in all of this?

"That's what this game's about: love," Sarah says into her gold microphone. "Gotta love it."

Hawaii is at 607. Ohio is at 500. At the end of each game, Michelson's young daughter, Prudence, runs onstage in a different colored unitard screaming

"Blue!" (or whatever color she's wearing) and does cartwheels in the middle of the space. "There goes that blue girl," Michelson says into the microphone.

Every once in a while there is something called "Grief Practice." A dancer begins to cry then lies down on the stage, sobbing uncontrollably. When this happens (usually it's Hoobyar or Mannarino), Wilcox walks over and holds a microphone to the dancer's mouth, a sad spectacle. A judgment is announced afterward, usually "Perfect Grief." But sometimes the grief isn't "perfect," and you can't tell why.

SATURDAY, SEPTEMBER 26. GAMES 10–12

After the airport, you and Laris Cohen have lunch at French Meadow Bakery, down Hennepin. You arrive at the Walker a little before 4 p.m., just in time for Game 10. The theater is empty except for a few new arrivals: the artist Claude Wampler in from Virginia and choreographers Moriah Evans and Gillian Walsh from New York. It's Ohio vs. Hawaii. Evelyn Champagne King's "Love Come Down" plays.

The music is perfect and the dancers are beautiful, but you're learning nothing new about the piece and you're suddenly filled with uncertainty. You have made a mistake.

You leave the theater and go to the parking lot, where you sit in your rental car, not sure where else to go. On your phone you read an e-mail about *tournamento* from a friend: "Our individual realities may be played by rules only one of us can understand. And I definitely think it is about the dilution of the spectator's gaze. The distraction and atomized attention of the technological age made visible. More I say!!!"

Are you here just to prove that you're hard core, to earn your twenty-hours badge? You want out of the mess of interpreting the work, of this overdetermined hide-and-seek, a tease and test to the acolytes.

You pull yourself together and go back to the theater. You've changed your plane ticket, and there's nowhere else to go. Believe or don't believe. Whatever. This is what you're here for, and, as much as you'd like to, you can't get away from your body, from these circumstances.

"Impressive games from Oregon and SoCal last couple of days," Michelson is saying. "Not sure about Ohio. Not sure she played well."

"Should it affect their ABI?" Wilcox asks.

"Clarity is clarity. Fatigue doesn't necessarily affect clarity," Michelson says.

"Strategy keeps them from effective play," Wilcox says.

"The game is the game," Michelson says. "Each player plays their own game."

One of the great pleasures of Michelson's work is that you can't imagine anything remotely like it happening anywhere else on earth. But sometimes this is its challenge, too: that it knows its specialness too well.

Anywhere else on earth. But usually this is anywhere but New York. Manhattan is the great modern transmitter, the place you go to do things so that people will talk about them everywhere else. But right now you're not in New York. This is the rest of America, its supplement. The space of regionalism: Oregon, Hawaii, Southern (why Southern?) California, Ohio. *tournamento* is a story of immigrants, of dancers who made their way to New York and then flew to Minneapolis to spend their bodies in the center of the country. The competition is futile, and you think of Michelson's description of the origins of *Dover Beach*, of sitting in a tiny ballet class in Wales watching young dancers "throwing themselves up against this archetype in the middle of nowhere, for nobody." But here at the Walker we are neither nowhere nor nobody. This place is a touchstone for Michelson and for a crowd of special makers. And where the archetype in Wales was capital-b Ballet, here it is the sporting event, of the sort, perhaps, that brings a country together.

Today's games seem to go on and on, much longer than the last two. Only three games in five hours.

Ohio wins Game 12 against Oregon by one point—126 to 125.

SUNDAY, SEPTEMBER 27. GAMES 13–16

Oregon plays Hawaii and SoCal. Sometimes only two dancers compete, sometimes three; you're still not sure why. At the beginning of each game, the dancers each stick a colored knife into an apple, and a girl with lavender hair closes her eyes and pulls one out. The color of the knife determines who is in the game.

There's a different energy in the room today. There's a whole new audience, a group of curators and artists arriving for "New Circuits: Curating Contemporary Performance," an invitation-only conference that begins Monday. Judy Hussie-Taylor of Danspace. Thomas J. Lax and Ana Janevski of MoMA. Kristy Edmunds (UCLA), Chris Sharp (Le Mouvement), Aram Moshayedi (Hammer Museum). Michelson doesn't seem pleased. It's not for them, she seems to say; it's for Minneapolis and for those who came just for this dance.

Now, at last, there are real outsiders.

You home in on smaller things, looking for clues, ways to get ahead of the game and ahead of these new viewers. The dancers sometimes wear cotton Soffe shorts and Asics kneepads. Generic but stylish. You don't know why this makes a difference to you; you don't know what you're looking for anymore. After fifteen hours in the same room, you spend a lot of time looking for new things

to notice. Sometimes a young woman with large glasses leaves off scribbling on notecards to peel up scuffed colored tape from the stage and replace it with new tape. Evans, who danced in *Devotion Study #1*, says it reminds her of the maddening practice with which they began rehearsals for that work: the dancers taped a grid across the entire floor and then had to remove it at the end of the session, before the next choreographer came in to use the space. (Gentrification practice: life in New York without your own dance studio.) Evans has secret knowledge. You look in the work for your own reflection.

Hawaii does "Grid Work," in which she seems to follow squares of tape on the floor as Wilcox walks around, monitoring: "4243—Perfect; 413—Perfect; 4 Update 5; 5-1 Perfect . . . "

Tyson seems to be in charge of something called "E" (Energy?). He calls out numbers between 2 and 2.5.

"EST," you later learn from Michelson, stands for "Element, Scoring, Training." "Exhibition" mode is that, plus . . . something else. The dancers can request "EST." Other terms you hear but don't understand: "Upcount." "Capture." "Discrepancy ['Low' or 'High']." "E-Range." "Pattern Flag." It feels like cult terminology or the language of an alien sport.

There's also "Granular," and you love the word and the dance that comes with it. It's one of the few moments when it's easy to look at *just one thing*. For "Granular" a dancer gets on the platform at stage right, and the lights shine on her as she sustains elegant shapes, detailed positions. Wilcox walks around the perimeter, calling out numbers. After, one of the dancer's attendants does her own strange and beautiful dance. For all this, a score is awarded.

Michelson: "Many years of training for these four days, and the stakes are high."

You come and go. You drink wine from the bar. You walk around the stage. Nothing you do makes a difference.

In 1963 Cunningham made his *Field Dances*, inspired by the sight, out a window, of children playing on the street below. Dancers worked from a set of calls and responses and movements (a man sits on the floor, one or more of the woman dancers go to him, put hands on his shoulders, and do a jump), but they could choose the sequence and when to leave and enter the space, could find their own speed, could decide how to complete the movements. You think of an even earlier dance, Balanchine's 1957 ballet *Agon*, one of the paragons of modernism. It's just dancers, frontal, on a stage, without even the distraction of a corps or elaborate costumes. In ancient Greek, *agon* is a term for an athletic game, and the dance is a competition of styles: not just ballet but jazz and Spanish dance and pedestrian movements sped up and fractured so they resemble a Balanchine dance. The dance styles of *tournamento* are not a pastiche of historical

techniques but extensions of the vocabulary of Michelson's Devotion series, combined in a continual distillation that makes the whole thing more and more hermetic, epic in a Lukácsian sense. Away from the old canon. But toward what?

Oregon and Southern California's scores are too low. Neither can win. You're sad for Oregon. Hoobyar seems so earnest, so affected by the whole thing. His dancing over the past three days has been beautiful, athletic. Lafferty is brilliant and virtuosic, but this is her first time dancing for Michelson, so your bet was never on her. The final Game, 16, is Hawaii versus Ohio.

"Hawaii!"

"Ohio!"

Hawaii does a Granular. Then Ohio. Hawaii begins to cry. "Perfect Grief."

The drama of *tournamento* is not narrative; it is, rather, the tension of the *sportif*. You saw this tension first in *4*, which thematized the primary ambivalences—about what makes dance its own thing, not pedestrian, not gymnastic. But in *4* a choreographic structure was still present. *4* was still a dance. And you begin to consider that perhaps the *sportif* was there in *Devotion* too, that it might be its animating principle, from Hullihan's running at the climax of the work to the use of Tharp's *In the Upper Room* as a motif—"the piece in which aerobics are made cosmic," as Arlene Croce once described it.[70] In *tournamento*, the track meet is made empyreal.

Then: "Game complete, scores pending."

Tabulations.

"Hello. Cancel Ex. Good night."

Final scores:
 Hawaii: 4,135
 Ohio: 4,107
 Southern California: 3,477
 Oregon: 2,958

And Hawaii is unceremoniously pronounced the winner.

It's done. On the floor of the stage, as at the end of each of the four nights, five overlapping projections of Charlotte Cullinan's iconlike portrait of the choreographer create a beautiful lenticular rainbow. People buzz around, snapping pictures of it.

You run into Berman in the mezzanine upstairs and congratulate her. She looks confused. "For what?" Everyone seems distracted. We're like docile animals just released from a petting zoo, meandering. People are peeling off for dinner.

You can't do it. You're still stuck on the dancers' heroism and the blasted field they left behind. Your doubts coalesce and form a perfect, narcissistic memory piece. *Your* pain, *your* inability to understand: faced with the work's radical strangeness, the end of contemporary dance as we know it, you make it personal. You think: Who the hell am I, here in the split of Split City? Essayist? Critic? Insider? Spectator? "*tournamento* didn't piss me off like it did most of the highly sophisticated audience," Ralph Lemon writes. "I thought its anti-audience container wondrous. . . . There was more (centripetal) rigor holding it together (barely) than in any dance I have ever seen."[71] You exit the theater with Claude Wampler and walk north, looking for the blood-red supermoon eclipse. When you find it, it's a moment of real beauty: that single thing hanging in the sky, shared by some three billion people on Earth, super special but not special at all. You wish that you were seeing it from New York. "It's the end of the world," you say.

"Really?" she says. "Want to get a drink?"

You do.

Two months later. November 20, 2015. We're back in New York, back at the Kitchen. It's 4 p.m., and a small crowd is here to witness the end of Devotion.

We sit in the black box's regular, everyday risers, facing a large bank of stacked white poufs, the seating from *4*, each individually wrapped in a clear trash bag. Michelson sits facing the stage in front of a pair of open MacBooks. She stands up to speak to the audience.

> *I thought I should explain the situation. So, about two weeks ago, I get an e-mail from Barbara* [Bryan, her manager] *saying that I have to do a show before December 31st of this year, or give $7,000 to NYSCA* [New York State Council of the Arts], *because they gave me $7,000 to do a different show that I had to cancel because I had surgery. Some of you, most of you, know about that. But I forgot that I was going to have to do a show, so I'm not prepared to do a show. But I don't have $7,000, so I have to do one. So a miracle, I wrote an e-mail to Matthew* [Lyons, at the Kitchen,] *saying, "Are there any dates before December 31st?" And he was like, "How about the 21st?" And I said, "Well that's Prudence's birthday, so that's not gonna work." And so then he said, "OK, the 20th." So here we are. We had some meetings. And I culled some shit together.*
> *And then, so a day or two after, sleepless, I'm like, "How am I going to do this? I just did a show. I really blew my wad." So this is even more*

unexpected than any other time. That show we did in Minneapolis was a really crazy experience. So I was lying awake thinking what the fuck am I going to do, and I get another e-mail from Barbara saying, "We have a really serious problem because you, Sarah, once again did not take a commissioned show to Minneapolis. You actually decided you couldn't do that, couldn't repeat yourself, and you made a new show with no money." So I did do that. Is this boring? So I did do that because I couldn't help it. I can't do that somehow. So what that meant on top of everything else is a lot of people didn't get paid very much, some people got paid nothing, and even with that case we spent everything we had. So we don't have enough money to pay for storage for these [points at poufs]. So now we've got to figure out a way to sell them. So I'm not really expecting you to buy them, but if you want to buy them, we've set up a way for you to buy them. They're from the show that didn't go to the Walker, that was at the Whitney. They cost $97 to make, and we're selling them for $200, and there are about 130 of them. So if we sell those, all our problems are basically over, short-term. Right, is that correct, Barbara? [Barbara: "Yeah."] They were seats for the show. They have a Northern Soul patch on them that I adapted. So that's happening. This is Moriah Evans. And she has that machine where she can swipe credit cards. And every twenty minutes she's going to remind you that this is a sales event and that you can buy one of these. And also, while we're working, if you want to ask any questions you can, but you have to ask her, and then she'll ask me, and then, if I can, I'll get to it. If I can answer, I will. So all that.

And then— I'm almost done. And then— So now what we're gonna do— We actually don't know what the hell we're gonna do. We did come back from tournamento totally kind of devastated, as I said, and I am now treating this as a very beautiful opportunity to go back to work. Which is really great. It's really weird. So there's a 4 p.m. and a 7 p.m. show advertised. But that's because for NYSCA you have to say you're doing two shows. But actually we're just probably gonna keep going. Yeah. I'm not imagining that everyone will want to stay five hours, so feel free to leave. Don't feel you have to stay at all. And yeah. We don't really know what we're going to be doing. We're gonna be working. We're definitely dealing with relics and detritus from the whole Devotion series and then, weirdly, thinking that it finally ended in Minneapolis but of course it's ending now. Here. With all of us. So, I think that's it.

Does anyone have any questions up front here? If you don't know, just know I never, ever, ever do this. I never do a fund-raiser. I never do a send-out letter. And I never talk at the thing. Sorry. ["How do we get the stools home?" someone asks.] How do you get the stools home? You take a taxi. When you leave, whenever that is, if it's in five minutes, Moriah and I will get you one. Alright, so. I'm sorry. Wish me luck. I don't know what we're gonna do. But we're gonna do something. Here we go. OK.

Oh, and also, last thing, there's also gonna be video. I recently learned to operate video, so I'm pretty proud of myself, but I have had like literally only a couple hours to work with what I'm working with here, so it might be back and forth, stop and start. I can't . . . Possibly I'm a really horrible artist, but, you know. And, final thing. For those of you who have been close in to Devotion, *this is sorta a David Velasco thing where he's like, "There's* Devotion *and then there's* Study #1 *and then there's* Study #3, *so where's* Study #2?" *Right?*

And then, on the speakers: "Scene. Sarah Michelson and Richard Maxwell sit in Wassily Chairs . . . " A hand-drawn animation of *Devotion Study #1* is projected across the poufs. Here's the mysterious *Study #2*.

The stage is empty. Wilcox walks across and grabs a chair and tips it slowly until it's balanced on one leg. She holds it like that for many minutes, appearing to struggle against it, until it falls over and she walks away and sits down at a table. Mannarino runs onto the stage: "Ohio!"

For James Tyson retains many elements of *tournamento*, including the costumes and the four core dancers, who do the same sets of elements, score one another, and join in dialogue with Michelson. But in feeling and structure it couldn't be more different. It's quieter than *tournamento*, like *Shadowmann: Part 2*'s contraction of the spectacle of *Shadowmann: Part 1*. Even when Lafferty screams—"Auto! *Arrrrrgghhh*!"—Mannarino and Hoobyar and Berman continue their work on their components. Michelson keeps up a banter with Wilcox as they evaluate the action, Wilcox scoring the participants. But the pressure of "winning" has been removed, along with many of the alarums and excursions of the last piece. No crazy lights. No Greek chorus of young dancers. No scoreboard. No minders or cheerleaders or interruptions of "Let's *plaaaaay*!" (Does this make things harder or easier for the dancers?) And we can ask questions.

5 P.M.

Moriah Evans: "So, Claire has a question."

Michelson: "I thought that might be coming."

Evans: "Claire would like to know what the letters refer to."

Michelson: "Oh, well, that's like saying, 'What do the words in the dictionary mean?' There's a lot of letters. Claire."

Evans: "Claire would like an example. Three would suffice. Like 'DP.'"

Michelson: "Ah ha. I'm gonna come back to that."

(Michelson: [*Without microphone*] "I want to admit right up front I feel rusty on this." Wilcox, resigned: "Me too." Hoobyar: "Is there anything in particular you want to work on?" Wilcox: "Um, no. Everything." Hoobyar: "K. *OREGON!*"

Wilcox: "GE 1.5." Hoobyar: "2LPF. GP2 capture." Michelson: "Discrepancy high." Wilcox: "Agreed.")

Eight minutes pass.

Michelson: "EST is 'Elements, Scoring, Training,' Claire. C1D: 'Competitive Element 1, Demonstration.' SCP: 'Single Competitive Practice.' Claire."

Evans: "Sarah, we have a question from David. 'What is black music?'"

Michelson: [*Laughs*] "Something that Ralph Lemon thinks about."

<center>5:12 P.M.</center>

Evans: "I have a question from Jeremy. Since we were speaking of Ralph Lemon, who has said multiple times that your choreography is the whitest thing he's ever seen, what does whiteness mean to you and in your work?"

("Ohio!" Mannarino yells, charging into the space.)

Michelson: "That my work's very personal. Jeremy. I don't think I've thought about that at all except why Ralph's said it."

("L2," they shout. "IA5!" "Capture!" "B1F1!" "L7!" "No score Ohio.")

Michelson: "What does he mean when he says that? Jeremy. Do you know what he means?"

A short loop of the hook from Adrian Gurvitz's "The Way I Feel" plays over the speakers, mixed by DJ Sarah. Michelson loves an Englishman's opening riff (Uriah Heep, New Order) carved from the rest of the song, that little moment of anticipation, drawn and quartered.

Evans: "We have a question from Nikki. 'Should we buy two poufs or one?'"

Michelson: "I'll have to get back to you on that, Nikki. [*Pause*] Probably one's enough. Nikki."

(Wilcox: "No score Ohio." Mannarino: "L6.")

<center>*5:17 P.M.*</center>

Evans: "We have another question from Jeremy. Jeremy wanted to tell you that there's no way he can know what Ralph Lemon means. But he, Jeremy, is interested in whiteness, specifically the whiteness of your dancers. Particularly in *Study #1*, considering the white woman in an Afro. And Jeremy says he started to think about American soul and that he feels, himself, that the soul of America lives in the black/white divide, and he just wanted you to respond."

(Lafferty screams, over and over: "Bunny no. Bunny you go. Bunny *NOOOOOOOOOOOO*! Puppy stop! Shut up!")

<center>*5:27 P.M.*</center>

Michelson: "Um, Jeremy. When I said that my work's very personal and that, honestly, I'm a white woman, I wasn't being flip. I think what Ralph Lemon is talking about is me. He's talking about Manchester, Northern England, and how he sees that—I guess the American way would be white-trash culture—in me. And I think that I do in some ways aestheticize that. Not in an experiential way, but in a guttural way. To figure myself out. That's an embarrassing answer. Jeremy."

Time passes.

<center>*5:38 P.M.*</center>

Evans: "We have a question from Connor. 'Do you support an ethics of domination?'"

Michelson: "No. How's that, Connor?"

Evans: "Great. Are you ready for a new question?"

Michelson: "Totally."

Here we are. A dialogue on dance. Only two hours in, and the audience is down to a handful. The focus comes easily. We sit and think of questions, chat

among ourselves. This is New York and we're among friends in a place we've all fought to call home. We text and take pictures. Sometimes we wander behind the poufs, where Hoobyar or Mannarino or Lafferty or Berman are stretching when they're not onstage.

<div align="center">

5:44 P.M.

</div>

Evans: "This one is from David. 'Why New York?'"

Michelson: "Hmm. It has seemed and still seems to be the only place for me to stay really low to the ground with some of the questions I have, and to stay out of the marketplace to some extent. And just work. There's a way that life here is brutal, as we know, but the work still seems to be in the lead. I don't know if it's like a legacy thing. The history of—I'm just gonna say 'dance,' but you know what I mean. But my dance lineage and the manifestation of that here, in the streets of this city, is tangible. And so then how does my inquiry in real time . . . My inquiry is not impositional but developmental, from the source of these questions. I would be so bold as to say that. But I wonder that sometimes. If it's to do with— Because of some [*garbled*] about. And away from . . . monarchy."

Then there's a moment we all love: Michelson blares Donna Summer's "Heaven Knows," and Wilcox walks to the center of the stage and does something called "DBJ." I don't know how we know that's what it's called, and I certainly don't know what it means, but I know that it looks like a secret, like we're watching someone who's pulled down the shades and is just dancing alone in her bedroom, as if no one were watching. But maybe someday someone will watch her, and she'll want it to look like this.

<div align="center">

6:32 P.M.

</div>

Michelson: "I see how the hard core remain, by the way."

Evans: "Just another interruption to remind you that another twenty minutes has passed, and that 120 poufs still remain."

Michelson: "I feel like you could have given a Triple WI or something, inclusive. You could have given a triple inclusive on it."

Wilcox: "A triple."

Evans: "We have another question from David. 'Sarah, when can we talk about the book?'" [*Audience laughs*]

No answer.

You can tell that everyone wants to get it, this special stuff. As if understanding would make the work more glorious. But the special stuff is just being in the room, enjoying the wanting to know. Intimacy is an illusion, as perhaps it always is. And who the hell are we? Essayists? Critics? Insiders? Spectators? Maybe it doesn't matter. Here we are, a tiny devoted audience of and for the Kitchen and dance in New York, watching and listening and asking for five hours.

Michelson: "A triple inclusive. So you could have given that or like an RJ, or whatever. You know what I mean? It was complicated, that one. Because the element was not clear, but the intention was very, very clear . . . "

As always, only the hard core remain.

NOTES

Epigraphs. Elizabeth Hardwick, "Cross-town" (1980), in *The New York Stories of Elizabeth Hardwick* (New York: New York Review Books Classics, 2010), 155; Walter Sorell, "Notes on George Balanchine" (1970), in *Repertory in Review: 40 Years of the New York City Ballet*, ed. Nancy Reynolds (New York: Dial, 1977), 17; quoted by Yvonne Rainer in Chrissie Iles, "Life Class: Interview with Yvonne Rainer," *frieze*, June 7, 2006, https://frieze.com/article/life-class.

1. Gia Kourlas, "A Nonconformist with a Free-Flowing Fantasy," *New York Times*, August 25, 2002.

2. Christopher Reardon, "Back on the Boards, but Haunted by an Injury and the Rent," *New York Times*, June 14, 2005; John Rockwell, "Cats, Cooked Chicken and Abundant Ideas, but No Sign of Man's Best Friend," *New York Times*, October 20, 2006.

3. Joan Acocella, "Mystery Theatre: Downtown Surrealists," *New Yorker*, August 8, 2005, 97. The other three choreographers discussed were Tere O'Connor, Christopher Williams, and Lucy Guerin.

4. Alastair Macaulay, "Looking Inward, and Finding Inspiration," *New York Times*, January 27, 2014. Art historian Catherine Damman responded: "Is there anything more terrifying than female ambition? Perhaps only her desire, that strange and mutant thing." Damman, "Performance Review: *4*, by Sarah Michelson," *Women and Performance: A Journal of Feminist Theory* 25, no. 1 (January 2015): 109.

5. If I rely almost exclusively on journalistic accounts, it's because the living world of recent dance, slow to be absorbed by the academy or the market, has largely been ratified through a few key media outlets—most importantly the *New York Times* but also, occasionally, the *New Yorker* and *Time Out*, as well as more and more forums devoted to the visual arts, such as *Artforum*, *Art in America*, and *Bomb*. In the last decade or so, however, mainstream dance journalism has undergone a sharp and dramatic disintegration. See Madison Mainwaring, "The Death of the American Dance Critic," *Atlantic*, August 6, 2015, http://www.theatlantic.com/entertainment/archive/2015/08/american-dance-critic/399908/.

6. Macaulay, "Looking Inward." For Yvonne Rainer's "NO manifesto," see note 48 below.

7. Sarah Michelson in Trajal Harrell, "Sarah Michelson Interview," *Movement Research Performance Journal*, no. 40 (2012): 21.

8. T. J. Clark, *Farewell to an Idea: Episodes from a History of Modernism* (New Haven, Conn.: Yale University Press, 1999), 401.

9. Deborah Jowitt, "House-to-House Sighting," *Village Voice*, April 9, 2003.

10. RoseLee Goldberg, "Sarah Michelson's *Shadowmann*," *Artforum*, June 2003, 192.

11. Annette Michelson, "Yvonne Rainer, Part One: The Dancer and the Dance," *Artforum*, January 1974, 58.

12. Michelson in Kourlas, "Double Trouble," *Time Out New York*, March 27, 2003, 73.

13. Michelson, "1000 Words: Sarah Michelson Talks about *Dover Beach*, 2009," *Artforum*, May 2009, 216.

14. Rainer, *Work 1961–1973* (Halifax, Canada: Nova Scotia College of Art and Design; New York: New York University Press, 1979), 328.

15. Brian Seibert, "Five Figures Circling, Backward, across a Blueprint of the Whitney," *New York Times*, March 7, 2012.

16. George Balanchine, quoted in Jennifer Homans, *Apollo's Angels* (New York: Random House, 2010), 470. Homans cites the *New York Herald Tribune*, April 9, 1944 (reprinted from *Dance News*).

17. For a closer reading of Tyrese Kirkland and Gary Levy's role in the dance, see Ralph Lemon, "B Sides," in this volume.

18. For a description of *Blister Me*, see Casey O'Donohoe, "Disinfecting Dixon Place," *Columbia Daily Spectator*, April 10, 2000, 9.

19. O'Connor, "Sarah Michelson in Conversation with Tere O'Connor," *Critical Correspondence*, September 19, 2006, https://movementresearch.org/criticalcorrespondence/blog/wp-content/pdf/Sarah_Michelson_9-19-06.pdf.

20. Acocella, "Mystery Theatre," 94.

21. O'Connor, "The Literalists," *Dance Insider*, August 26, 2005, http://www.danceinsider.com/f2005/f1014_2.html.

22. Michelson, "1000 Words," 216.

23. Ibid.

24. This style recalls the primal "scooping" gesture, also executed by four dancers in unison, at the climax of *Shadowmann: Part 1*.

25. Michelson in Reardon, "Back on the Boards."

26. Rockwell, "Elusive Meaning from Potent Movement," *New York Times*, June 17, 2005.

27. For more on "irresponsible noises," see Jill Johnston's collection *Marmalade Me* (New York: E. P. Dutton, 1971), and Bruce Hainley, *Under the Sign of [sic]: Sturtevant's Volte-Face* (Cambridge, Mass.: MIT Press, 2014).

28. O'Connor, "Sarah Michelson in Conversation."

29. In 1967 photographer Danny Lyon recorded the demolition of nearly sixty acres of nineteenth-century buildings south of New York's Canal Street. The pictures were published in 1969 as *The Destruction of Lower Manhattan* (New York: Macmillan).

30. Cynthia Carr, *Fire in the Belly: The Life and Times of David Wojnarowicz* (New York: Bloomsbury, 2012), 4.

31. Acocella, "Mystery Theatre," 94.

32. Consider that, in 2014, professional art critics—Jerry Saltz for *New York* magazine—and curators—Lynne Cooke for *Artforum*—named *4* in their end-of-year "best of" lists devoted to art exhibitions.

33. Macaulay, "Looking Inward." "Terpsichore in Sneakers" refers to Sally Banes's 1980 book of that name, a touchstone for studies of Judson Dance Theater.

34. Claudia La Rocco, "Four on the Floor," *Artforum*, February 5, 2014, http://www.artforum.com/slant/id=45152.

35. The dances of Balanchine and Merce Cunningham also used "pedestrian" movement—along with countless more or less eccentric and vernacular vocabularies—and part of the excitement of their works is this dramatic tropism toward that which has been purportedly excluded.

36. Consider the title of one of Banes's investigations: *Democracy's Body: Judson Dance Theater, 1962–1964* (Durham, N.C.: Duke University Press, 1993).

37. For an incisive consideration of Trisha Brown's subversions of and capitulations to the "frame," see Craig Owens, "The Pro-Scenic Event," *Art in America*, December 1981, 128–33.

38. See, in this context, Douglas Crimp's important consideration of the role of the frame in Balanchine's brand of modernism in his 2012 essay "Agon," in *Before Pictures* (New York and Chicago: Dancing Foxes Press and University of Chicago Press, 2016), 203–35.

39. Lincoln Kirstein, "Rationale of a Repertory," in Reynolds, *Repertory in Review*, 6.

40. The athletic spirit was also a subject for Twyla Tharp's *In the Upper Room*, of 1986, the dance in

which "aerobics are made cosmic," as Arlene Croce wrote in a *New Yorker* review. Can we wonder anymore at Michelson's fascination with this dance? See Croce, "Postmodern Ballets," *New Yorker*, February 23, 1987, 120.

41. Consider, too, the constitutive role, typically antic, that the *sportif* played in certain dances of the Judson Dance Theater (the baseball allusions in Steve Paxton's 1962 *Proxy*, the use of ball games in Rainer's *Terrain* and the wrestling in Judith Dunn's *Speedlimit*, both of 1963) as well as some of Cunningham's dances from the same period, such as 1965's *How to Pass, Kick, Fall, and Run*. For a discussion of the difference between "sports" and "frolic" in the latter work, see Crimp, "Four Events That Have Led to Large Discoveries (about Merce Cunningham)," in the catalogue for the exhibition *Merce Cunningham: Common Time*, at the Walker Art Center, Minneapolis, and the Museum of Contemporary Art, Chicago, opening at both venues in February 2017.

42. Don McDonagh, *The Rise and Fall and Rise of Modern Dance* (New York: New American Library, 1970), 286. See also Julia L. Foulkes, *Modern Bodies: Dance and American Modernism from Martha Graham to Alvin Ailey* (Chapel Hill, N.C.: University of North Carolina Press, 2002), 116: "University and college physical education departments created a vital base for modern dance." Doris Humphrey, Foulkes claims, called it "the despised physical education department."

43. One might consider, too, the emphasis Martha Graham placed on a stylized pedestrianism in many of her early works. "During the 1930s Graham took time to develop 'the beauty of a walk.' Dorothy Bird explained that it was quite usual to spend an entire year working, for example, on 'a fantastic walk from *Primitive Mysteries*.'" Henrietta Bannerman, "An Overview of the Development of Martha Graham's Movement System (1926–1991)," *Dance Research: The Journal of the Society for Dance Research* 17, no. 2 (Winter 1999): 15.

44. It could be argued that the somersault belongs to that family of movements we call pedestrian—almost everybody has performed one—though, of course, this analogy strains the essential metaphor: somersaults are one of the very few methods of traveling that *don't* require feet ("pedestrianism").

45. "My works are not reproducible in any practical way—each piece is made for a very specific context and includes a very specific group of people. They even take into account a specific group of peers—the audience at the Kitchen, dancers within the European festival touring circuit—and each dance is related to the dances that preceded it. I don't expect anyone else to give a fuck about this, but if anyone *does* care about me as an artist, then you have to know that context is crucial." Michelson, "1000 Words," 216.

46. Michelson in Ralph Lemon, "Sarah Michelson," *Bomb*, no. 114 (Winter 2011).

47. Compare the compatibility of this sentiment with one from Balanchine: "I am only interested in these people I am surrounded with, I am working with; these people who are looking at it and these people who are dancing it. I like to live now, today. What will be ten years from now, one hundred years, who cares? One hundred years from now there won't be the ballet as we're doing it today. Just like one hundred years ago you'd laugh if you saw Carlotta Grisi or Taglioni dance today. We have got to enjoy the now." "Mr. B Talks about Ballet," *Life*, June 11, 1965.

48. Rainer, "Some Retrospective Notes," *Tulane Drama Review* 10 (Winter 1965): 168–78.

49. Guy Debord, *The Society of the Spectacle*, trans. Donald Nicholson-Smith (New York: Zone Books, 1994), 14.

50. Ibid., 17. It is a much easier sense to fool than touch, which is perhaps the most sensible sense, Debord argues. And so, one wonders whether Helen Keller—whose regular visits in the 1930s and '40s to Graham's studio, where Cunningham, then a member of Graham's company, taught Keller what it means to jump—might have been dance's most capable witness. "Oh, how wonderful! How like thought! How like the mind [dance] is!" Keller told Graham as she felt Cunningham move. See Craig Brown, *Hello Goodbye Hello: A Circle of 101 Remarkable Meetings* (New York: Simon & Schuster, 2012), 16.

51. This informal conversation among Claire Bishop, Nikki Columbus, Stuart Comer, Kathy Halbreich, Adrian Heathfield, Ralph Lemon, Ryan McNamara, Michelson, Samuel Roeck, and others took place on June 23, 2014, after Bishop's *Tour: MoMA 2064*, her contribution to Lemon's project Value Talks, part of his Artist Research Residency at The Museum of Modern Art.

52. Crimp, "Dancers, Artworks, and People in the Galleries," *Artforum*, October 2008, 346–55.

53. Carol Lambert-Beatty, *Being Watched: Yvonne Rainer and the 1960s* (Cambridge, Mass.: MIT Press, 2008).

54. Crimp, "Dancers, Artworks, and People," 351.

55. Ibid.

56. The fact that this dance behind the audience in *Daylight (for Minneapolis)* is a reprise of her *Love Is Everything*, made originally for the Lyon Opera Ballet in 2005, enlarges the "seeing problem" into a "knowing problem"—for who could know this but the most dedicated fan?

57. Michelson in Lemon, "Sarah Michelson by Ralph Lemon."

58. The limousine, in particular, is a persistent trope in the literature on the 1980s East Village art scene. It is often the signpost for the neighborhood's rapid gentrification and consequent social collapse. See Sarah Schulman, *The Gentrification of the Mind: Witness to a Lost Imagination* (Berkeley: University of California Press, 2012), or Cynthia Carr, *Fire in the Belly: The Life and Times of David Wojnarowicz* (New York: Bloomsbury USA, 2012). This prophetic trope was parodied as early as 1981 in Gracie Mansion, Buster Cleveland, and Sur Rodney Sur's *Limo Show*. See Carlo McCormick, "Gracie Mansion Gallery," *Artforum*, October 1999, 123.

59. O'Connor, "Sarah Michelson in Conversation."

60. Michelson, "1000 Words," 216.

61. Ibid., 215.

62. Jennifer Homans, *Apollo's Angels: A History of Ballet* (New York: Random House, 2010), 540.

63. Fran Lebowitz in the 2010 HBO documentary *Public Speaking*, by Martin Scorsese.

64. "81,542 people have died of AIDS in New York City as of August 16, 2008. These people, our friends, are rarely mentioned. Their absence is not computed and the meaning of their loss is not considered." Schulman, *Gentrification of the Mind*, 46. This book is a gripping account of the impact of AIDS on gay politics and New York real estate and creative communities.

65. Ibid., 35.

66. Jacques Rancière, *The Emancipated Spectator*, trans. Gregory Elliot (New York: Verso, 2009), 7–8.

67. Claude Wampler in conversation with the author, August 28, 2015. See Wampler and David Velasco, "A Conversation," in this volume.

68. Jill Johnston, "Cunningham in Connecticut," *Village Voice*, September 7, 1961, 4.

69. Rancière, *Emancipated Spectator*, 3.

70. See note 40 above.

71. Lemon, "The Artists' Artists," *Artforum*, December 2016, 100.

A CONVERSATION

Claude Wampler and David Velasco

David Velasco: How did you first meet Sarah Michelson?

Claude Wampler: Sarah was working at P.S. 122, in the box office I think, when I made my show *Bucket (The Working Title)* there [in 1999]. I needed some people to participate, to make out in the audience. I think I paid each person fifty bucks to make out during the whole show.

Sarah found out about it. She signed up for the first show and then wanted to be part of it again, because she liked the show so much. She did all the shows. I didn't remember her name, but I remembered that remarkable person who had kissed throughout all my shows and who had a different partner every time! I thought that was so cool. I didn't really speak with her or hang out with her at all. Then I guess about a year later I was contacted by Sarah. She explained who she was, that she was one of the people who had made out during my show and that P.S. 122 had a mentorship program. P.S. 122 would pay the mentor a couple hundred bucks, and you would just be present for that artist, hang out and do whatever they needed or just give some helpful advice. She chose me to be her mentor for *Group Experience*.

I didn't know anything about her work. I didn't even know that she was a choreographer. Then I started coming to rehearsals. Or it was more like the mounting period, when they were installing in the downstairs space. I remember telling her something about the video not being strong enough to use. I remember telling her something about how difficult it is to work with dogs. That's pretty much all I could offer, because otherwise it was an amazing piece. She was fantastic and I was really, really excited to watch her work. That was the beginning.

DV: Could you describe *Group Experience*? Even though it's a touchstone, I've never seen video. I've only heard strange descriptions.

CW: She was using the basement space, and I don't remember anyone having done that before. I made many pieces at P.S. 122, and they were always upstairs in this stupid space where the pillars were right in the middle of the audience sightlines. It's way too wide and not deep enough, and the risers are static and complicated. Sarah used the downstairs space to create incredible intimacy with the audience.

I'm pretty sure she covered the entire floor with carpet. I remember thinking that she was a very good visual artist, because she was so complete in her vision. It was really an installation down there. She had covered every surface—not even just covered it but had *thought about* every single surface. She was thinking about the audience seating as stage, the floor as stage, the back wall as stage. The entrance and exit as stage, because the dancers entered and exited from just the hallway, basically. A shabby hallway.

It was a concrete floor and a metal staircase. It had a sort of bleak basement feeling. I remember she was fucking with that line of entrance and exit. She had already started taking on this idea of invisibility and questioning the privilege of the viewer to see the dance to begin with. Like do you even deserve to look at this dance? And I remember—again, this is just my memory—that there was dancing happening in that hallway that you couldn't even see from inside the audience. She'd already begun to go with that idea of the dance being off-camera.

Does that make it not dance anymore, because we can't see it? Is it part of the piece or is it not part of the piece? They were in relevé, I think, the entire time. She was already dealing with the endurance factor. It looked difficult, from a muscular point of view.

DV: Do you remember what the audience was like? I'm trying to get a picture of P.S. 122 in 2001 and who would have come to this and where it would have fit in that world.

CW: First of all, it was a tiny, tiny space. There weren't that many seats at the show, which was also very cool. Also, there were a bunch of dancers in it. It was a good group. Like eight, maybe?

They were dancers who were working with everybody and being shared by lots of choreographers, all longtime East Village–type performers. That alone created an audience, just each dancer and all their friends and Sarah having been on the scene. She was involved with lots of work before she started making her own. I think that's who her audience was, because she was so intrinsic to the lower Manhattan dance world, just by dancing for everyone, working for everyone, helping everyone. Like being in my piece and making out in my shows. I mean, she really was all over the place, like she still is.

She's remarkable in how much work she sees. She's very, very devoted to her contemporaries and making sure to see what they're making and making sure she knows what's going on. She was like that then, too. Therefore, she had a lot of friends and a lot of support from the very beginning. P.S. 122 was a real insider crowd. It just seemed like everyone knew each other and everyone was seeing everything there. At the Kitchen, on the other hand, it seems like dance people come to see the dance things, music people come to see the music things,

and so on. People that go upstairs to the art exhibits are not the same people that go downstairs to see the performances. P.S. 122, in its heyday, was not as rigidly categorized. The audiences had more flow.

DV: Do you think that might have had to do with the fact—this is just hypothesis—that there were more artists living in the neighborhood of P.S. 122 (the East Village) than the Kitchen (west Chelsea)?

CW: Yeah, definitely. Mark Russell also had a lot to do with it. Mark was a great curator/director for P.S. 122 back in the day. He liked what he liked and valued what he perhaps didn't like. He wasn't compartmentalizing performance art and dance. For him, if it was cool he liked it. He was excited by work and it didn't even have to be "good." It wasn't about quality, it was about innovation, which is why you could see such great things, because they were so fresh and sloppy. It's hard to see sloppy now, you know?

DV: When was your first piece at P.S. 122?

CW: 1996. No, wait, that was my first solo piece. Before that I had a show with two other artists. That was probably like '95. Before that I had a show in the building, but I was in residence with Mabou Mines. I had this cool residency where they gave me a studio to work in. I did how many solo pieces at P.S. 122 proper? One, two, three, four? It was a very intimate crowd. The one thing I remember that was annoying was how everyone laughed very readily. Everything was funny. Everything was ironic.

It was hard to get the more sincere or disturbing moments there. It was incredibly supportive, therefore there was a lot of laughter and a lot of the audience performing gratitude. At first I loved it, because I was like, "Woo, I'm doing really well here." Then after a while, you're like, "Wait a second, they just come to be cheerleaders and I'm not sure if they're even watching the piece." The performance going on by the audience was distracting to the work. That happens everywhere. That happens at BAM [Brooklyn Academy of Music].

DV: Sure.

CW: That's why watching Pina Bausch at BAM is so insufferable. When Pina was still alive, her last couple of years of showing work at BAM, you couldn't bear it, because the audience was performing their appreciation of this thing as opposed to appreciating it or being confused by it or not liking it or whatever. Everyone was like, "Oh, ho, ho, ho. I'm so amazing for being here."

DV: That reminds me of this Jérôme Bel piece, *Gala*, I saw in Brussels a couple months ago. It was very slapstick, but I think Jérôme wanted it to be disturbing or thoughtful or strange. Everything that happened, the audience was in laughter. Afterwards he came out and did a Q&A and he was like, "The piece isn't right because everybody thinks it's so funny." Of course, that's partly the problem that Jérôme set for himself. I think people go and assume that it's going to be funny.

CW: I mean, it is partly the artist's fault, because they have to be aware of how they're being consumed as they become more famous. Yeah, it is partly his fault, but it's partly just the way it is. When you become more popular, you're going to have an audience base that feels good about themselves for buying a ticket. That's a problem and a very corrupting force. This is my total obsession: an audience can really destroy a piece!

I've seen that happen with Sarah's work a little bit. Once the criticality goes and everyone is so into being in the crowd, then the work's got to either fuck with that, ignore it—which is an option, but probably not the best option—or go with it. The work has to make a choice about what it's going to do about that problem, because it *is* a problem.

DV: I was watching the Fran Lebowitz documentary *Public Speaking* the other night. She makes an offhand remark about something that should have been obvious but that I don't think I'd ever thought about. Which was that part of what decimated New York City Ballet in the 1980s was that AIDS essentially killed off this whole base of connoisseurs. That all these people who had held a certain standard for this kind of performance, who'd been devoted fans, a huge class of them just died.

CW: Mm–hmm.

DV: Of course, it seems even more so for the East Village and its dance world. What happened in the '80s and the early '90s, when a huge class of not just the dancers, but the audience, died? What effect did this have on people who were making work in the '90s? Certainly it must have had an impact, even if it wasn't being thematized or dealt with directly. To be making work during and in the immediate aftermath of a plague, how might that affect audiences?

CW: The thing that drew me to performance and dance was not just P.S. 122 and going to see Karen Finley and Ethyl Eichelberger, who was a huge influence, or Mimi Goese. It was also seeing the drag shows. Damn, what was that place on Avenue A called?

DV: Pyramid Club?

CW: Yes, the Pyramid. Going there and seeing that work—it was all the same people, it seemed. There was not a lot of difference between so-called high art and low art. Or just because something got staged in a more formal setting like P.S. 122—which wasn't even that formal, but more formal than the Pyramid, for sure—it was the same thing. It was part of the same movement. Just like Michael Clark and Leigh Bowery in London, there was this combination of what was happening in contemporary dance and what was happening in the clubs. There was a crossover: a costuming crossover, a movement crossover, a music crossover.

The Ridiculous Theatrical Company and the loss of [its founder] Charles Ludlam meant something. That was just across town, in the West Village, but still it was this sort of parallel work. Though we came a little bit later. We weren't in the thick of it when people were just dropping dead right and left. Or we were too young to understand the severity of the situation, maybe? Or Sarah and I weren't gay men, so we didn't have the same experience. Certainly the audiences and the stages were inhabited by these ghosts.

The biggest shock for me was Eichelberger. That's such a sad ending because he was so defeated. He killed himself in his bathtub [in 1990].

DV: I didn't know that.

CW: He got sick and he didn't want to die like all of his friends were dying. He didn't want to be a burden. He didn't want to waste away, so he killed himself, which was courageous and powerful but also just so fucking sad.

DV: My impression—again it's just an impression—is that in the '90s in the downtown dance world there was a lot of room for women choreographers and performance makers. Or the ones that I mostly *know about* were women. I can't help but wonder if that had something to do with a lot of the guys dying.

CW: Yeah, a lot of the guys dying and also the men, it seemed—I could be totally wrong, but this is my impression—the men, it seemed, were all doing this form of performance art that was monologue based. I just couldn't stomach it. I was paying attention to people who were making work blending performance art and choreography. Like Sarah. Sarah was giving as much attention to the technical difficulty of the dance as she was to the experience, which is what makes that work so good.

DV: There are three other things I'd like to hear about from you. You were in Venice in 2004 for that iteration of *Shadowmann*, correct?

CW: Yep.

DV: And then you also saw *Love Is Everything* in Lyon in 2005.

CW: Yes.

DV: And I really want to hear about your experience with *Daylight*, the same year, making the portraits.

CW: You know, the thing I saw that was really incredible: it was pre-*Shadowmann* and it wasn't even a piece really. It was sort of a cocktail party that happened in an Upper East Side, Fifth Avenue, beautiful '60s apartment building. A person that danced for Sarah and also made costumes for her—well, sometimes still does. Do you know who I'm talking about? She lives in LA now. She's an LA-based designer/choreographer. She's changed her name many times. Her name is or was James Kidd?

DV: Yeah.

CW: Sometimes she's called James Kidd. Sometimes she's called James. Sometimes she's called J something: JL, JB, JR. I know her as Jmy (pronounced "Jimmy"). Anyway, her. Her stepfather's parents moved out of their Upper East Side, Fifth Avenue, '60s building. It was a strange empty apartment but still had carpet and drapes and things like that, which is where the decor for the second part of *Shadowmann* [at P.S. 122 in 2003] came from, the white carpet and the floral drapes. She did a little piece for a very small audience—I don't remember how many of us were there, maybe six—in the master bedroom. It was extraordinary. It's really my favorite thing of Sarah's work so far.

DV: I've seen pictures. There's one of her and Greg Zuccolo doing something that looks like it was also in *Shadowmann*, some sort of gesture in this strange carpeted apartment.

CW: Somebody was operating the lights, which were just basically the switches on the wall, and they had beautiful underwear costumes on, as you can imagine. It was Parker Lutz and Greg and I believe Mike Iveson and Sarah. It was so strangely sleazy. Anyway, that's one thing that I saw that I feel so lucky to have seen. Then, chronologically . . . What was the first one you asked about?

DV: *Shadowmann.* I'm curious to hear about *Part 1* at the Kitchen but also what it was like to see it in Venice.

CW: I helped Sarah install it and just, like, make shit happen at the Kitchen and at P.S. 122. Then she invited me to come to Venice to do basically the same thing. I don't even know what that role would be called. That's when Sarah was in her pieces, so she couldn't be on top of every single detail. I made sure that all the physical elements were in place. There was a lot of management of this little troupe of young girls too. Also two completely different sets and the total vastness of the first part and then the very, very tiny sort of shrunken, tight, intimate space of the second part. It took a whole lot of work.

DV: What do you remember from the Kitchen?

CW: I remember Sarah being so specific about how everything looked in the space. She didn't leave one surface untouched by her hand, by her artistic idea of what things should look like. Even though it was very difficult and it created a great deal of extra work for everyone. There was a certain fabric that we had to line the risers with to create a curtain effect. We had to have a certain colored tape to attach it. There were all these little details that very few people would notice, that at their feet there was a certain upholstery fabric. It was all well chosen and carefully applied to the space, like a very good interior decorator.

What's great about Sarah is that this is just as important as any of the rest of the stuff. There's no prioritizing. It's all just as important as the choreography, as the lighting, as the music. As the source and the direction of the sound, too. Like with the first piece at the Whitney [*Devotion Study #1—The American Dancer*, in 2012], the source of the sound is off to the side and miniature. It's not only the choice of the sound but the quality of the sound and the direction from which it comes and what it's played out of.

At P.S. 122, for *Daylight* the risers were pulled away from the wall, so they weren't where they normally are. They were pulled away and there was a little space carved out for a live band to play. It was not an orchestra-pit-type situation, because they were behind the audience, but they were performing as if they were in front of the audience. If you made the effort to look at them while they were in performance—like if you stood up and walked to the back and peered over the back of the risers—you would have a completely different show. (Nobody did, I think.) The way that they behaved and what they wore and the lighting of those musicians, even though they weren't seen during the show, was just as important as everything else.

DV: Could you describe the experience of staging *Shadowmann* at the Biennale Danza, in Venice?

CW: I have memories of it looking really good there. The second half looked even better than it had at P.S. 122. Whereas the first part, it was in a huge,

more warehousey kind of space [the Venetian Arsenale], if I'm remembering correctly, so therefore it wasn't as dynamic as it was at the Kitchen. The Kitchen created levels of experience. You sat at a back wall on the risers and you looked at the space. Then the doors were opened by two women and you're looking at the lobby through those doors. Then through those doors, you can even see the outside door and you can watch the limo pull up. Do you remember that? Seeing that in the footage?

DV: Yes, definitely.

CW: To have all of those layers of space, it was more like a painting, like a Watteau. Are you familiar with Watteau's paintings?

DV: Not really, no.

CW: He was very theatrical. His paintings are also about levels of experience. You have the performers in front that are doing the main action, but then you have some bit players that are performing toward the middle. Then you have something weird and sort of scenic going on in the next level, in the far back. Then you have some crazy deep sort of scenic painting-within-the-painting. That's the way *Shadowmann* went down at the Kitchen. We tried to make that happen again in Venice, but the space just wasn't complicated enough. It was too nice, too forgiving, too malleable. It didn't have all the architectural challenges that the Kitchen did. We had to fake that. It wasn't as good.

I remember that being really fun, just aside from the show. I was about two-and-a-half months pregnant so I was sick most of the time. Having to take a boat everywhere was torture. I remember sitting outside these cafés after rehearsal or after we worked in the space. It was when the Michelson family was still close and healthy, from my perspective. Like Sarah and Parker's relationship was great. Mike was really great. Greg was perfectly fucked up and wonderful. Everyone was still completely devoted to each other and dependable in a certain way. It was kind of the heyday of that group of people.

DV: When you mentioned painting, it made me think about your portraits for *Daylight*. How did you end up doing those and why did you decide to do them the way you did?

CW: I had one of my solo shows at Postmasters very soon after *Shadowmann*, and I made a bunch of black-light paintings, filled the room with them. The lighting in the space cycled through regular exhibition lighting and black light. You could never look at the paintings that carefully because the light would change and you'd have to wait for the cycle to go through to be able to see them again.

A bunch of those paintings were made from stills of video that I had taken at rehearsals of *Shadowmann*. There were a lot of portraits of Sarah and Parker doing that beautiful section in the second half where they have their thumbs entwined and their palms facing the ceiling. Their arms are a little bent. Their heads are thrown back. Their backs are arched. They're doing a kind of hop step and throwing their hands and heads back. Can you imagine what I'm talking about?

DV: Yes, I know exactly what you're talking about.

CW: Sarah and Parker came to the opening of that show and they liked it very much. Sarah loved it. Then she asked me to make portraits for her next show, because she realized I could paint.

DV: How did you approach those?

CW: I wanted to do three-color portraits. Everything that's grayish gets one color. Everything that's black gets another color and everything that's white gets no color at all, just whatever color the canvas is. I took portrait photos of each dancer: Mike, Greg, Sarah, and Parker.

I asked Sarah what her color themes were, what was going on with the costumes, what was going on with the rest of the set. She told me and I decided what two colors to work with and what color the canvas would need to be, for them to go with the rest of the decor. I painted them there, at P.S. 122. They were on these big MDF panels. I painted one in the hallway. I painted one somewhere else. I just took over wherever I could make a little space for myself and painted them there.

DV: Did you also do all the portraits for *Daylight (for Minneapolis)*, later the same year?

CW: Yeah.

DV: Because there were a ton.

CW: I mean, we say that I did the portraits for *Daylight (for Minneapolis)*, but I had some time issues and so I couldn't just stay in Minneapolis and paint. We went to this high school for the arts. I spent a couple of days training students how to make the paintings and I organized the photographs. I fucked with them in Photoshop. Then I created something for them to project onto the canvases. Then I taught them my method. It ended up being a production line.

And all the paintings for *Love Is Everything*. I took all the pictures of the director of the Lyon Opera Ballet and the dancers. I organized and Photoshopped them and worked out the whole projection thing in the studio space they gave me,

which was a huge old factory building outside of Lyon. Every day I had to be driven to this crazy factory where all my paint, projectors, and canvases were set up. I had just had my daughter, Asa. She was only two or three months old, so I brought my sister along to babysit while I painted, but I was breastfeeding and had no idea what that was going to be like. I was a little naive about my energy level and the reality of an infant attached to my boob. What ended up happening was I sat around and breastfed while my sister did all those paintings.

She worked so hard. She's never worked that hard in her life. And not since.

DV: I've seen a video snippet of *Love Is Everything*, but Sarah's documentation is not great. I don't know much about the piece.

CW: Oh my God, that was so good. That was so good.

It was really the first time that Sarah cut loose from Parker and Mike and Greg. I mean, they were still present, but she wasn't dependent upon them because she had a ballet company to put the work on. It was incredible. I don't know if this is accurate, but for me it was like you could finally see the choreography—because it wasn't contaminated by the cult of personality that was Parker, Mike, Greg, and Sarah. It wasn't about ideas for these dancers, because they had no prior relationship to the work. It was incredible to see how gorgeous, stunning, and technically so clear and complicated her choreography was. It really worked. No need for the insider reinterpretations or the NYC laugh track.

Before, you always thought, "Oh, this is kind of a microcultural thing. You must have the composer/nondancer Mike. You must have unpredictable Greg, and he's got to have his powerhouse Parker to balance it all out. This *is* the work." It suddenly was like, "Oh yeah, none of that is necessary, and not only is it not necessary, it's better without it."

DV: I wish I could have seen it.

CW: It was really incredible. I mean those dancers were incredible and so was what she was able to achieve with them, because they were all of course totally devoted to her and the work by the end. She got the best out of them. It was really something. What it was in rep with was cool too.

DV: How so?

CW: I think it was a Trisha Brown piece [the 1983 *Set and Reset/Reset*], and Trisha was there.

DV: Oh wow.

CW: Yeah, it was one of three. It was also put in direct comparison with this other work [John Jasperse's 2002 *à double face*] that made it just super fine. I was totally high on oxytocin at the time, so I'm not sure how well my memory serves me, but it was a remarkable piece—gorgeous, disturbing, and funny. Parker, Greg, and Mike performed a song on the balcony at the back, behind the audience, toward the end. It was a throwback to the East Village. Like, "OK, we can't lose ourselves entirely. Let's put this in." It was interesting to see how that move doesn't necessarily work always and that nobody cares.

DV: I had thought that *Dover Beach*, in 2008, was the first separation from the crew, but I guess *Love Is Everything* was the moment where you first witnessed that independence.

CW: Yeah, and I think it was a moment where Sarah was dealing with the unprofessionalism of her crew, because they were close friends, in stark contrast to the professionalism of the dance company, and it was kind of helping her to be over it. It was bliss for Sarah to be with a dance company that was doing what they were told to do, as opposed to these fantastically difficult people— interesting, lovely, talented but difficult people—who weren't really even giving that much to the work anymore, you know?

I can say that because I wasn't part of the crew. I was Sarah's person, but I wasn't one of "the people." I had an outsider perspective of the dynamics of that group and how it was so hard for Sarah. She wanted total control, but with those certain people, because they were her friends, she couldn't get it.

DV: Her peers, yeah.

CW: I always promise Sarah, you know— I'm not, sadly, I've just never . . . I'm always going to be the voice of reason for her no matter what happens. Or not "reason," exactly. Maybe the opposite of reason? I'm not going to be in the group of people drinking the Kool-Aid, because I don't think that's helpful to her. She has plenty of those now. She doesn't need more of those.

DV: True.

CW: Because that's when it gets deadly. I mean just judging by watching other people, other artists and what they make after everyone falls in love with them. It's a dangerous moment.

LIST OF WORKS

All works choreographed by Sarah Michelson unless otherwise noted. Performers and other collaborators are listed where known.

1989
Cindy Camille Sheila and Shirley
New Performance Gallery, San Francisco (October). Performed in 1990 as part of Footwork Studio's series Cream, where Michelson won an award for best emerging gay choreographer. PERFORMERS Sri Louise, Michelson, and Sue Roginski

1993
Where God Is Now
Merce Cunningham Dance Studio, New York (April 9–10), with an excerpt from Cindy Camille Sheila and Shirley (1989) danced by Michelson and Sue Roginski with music by Oklahoma. PERFORMERS Louise Coles, Christine Knight, Michelson, Cheryl Therrien, and Kristy Zornes. COSTUMES David Quinn. LIGHTING Suzanne Poulin. MUSIC Roches, Dead Can Dance, Tori Amos, and Ani DiFranco

Glory (Glory Glory Glory)
Danspace Project at St. Mark's Church, New York (November 22), part of the program DanceGiving, organized by SenseDance. PERFORMERS Chris Bergman and Michelson. MUSIC Belly and Squeeze

1996
Spit and the Believers
Danspace Project at St. Mark's Church, New York (October 12), part of the program Food for Thought, organized by Alicia Newman. PERFORMERS Erika Kinetz, Sri Louise, Michelson, Julie Atlas Muz, and Jody Sperling. READERS Jennifer Chien, Michelle Levi, and Anastasia Sharp. MUSIC Oasis. TEXT Michelson

1999
Miami 3XLA
The Kitchen, New York (December 10–11), part of the series Dance in Process (now Dance and Process). CHOREOGRAPHY with Mike Iveson

2000
Blister Me
Dixon Place at Vineyard 26, New York (April 6–22), part of the series Mondo Cane! CHOREOGRAPHY with Julie Atlas Muz. PERFORMERS Michelson and Julie Atlas Muz. MELODRAMA COACH Gregor Pawalski. COSTUMES Michelson and Julie Atlas Muz. LIGHTING DESIGN Diane Fairchild. MUSIC The Electric Family, Michael Legard and The London Symphony, Chrome, Thinking Fellers Union Local 282, Boy Dirt Car, Mouse on Mars, and The Glass Mountain. MUSICAL DIRECTOR Mike Iveson. SET DESIGN AND CONSTRUCTION Michelson and Julie Atlas Muz with Tony Gill and Leonel Valle. TECHNICAL SUPPORT Erik Rune. "ROUGH SLIDES" Michelson and Julie Atlas Muz. "SMOOTH SLIDES" Nicole Botkir and Tony Gill

The New Aut Norm
P.S. 122, New York (April 27–30), part of the series New Stuff. Traveled to Congress Theater, Chicago (June). PERFORMERS Mike Iveson, Michelson, Julie Atlas Muz, Adrienne Truscott, and Tanya Uhlmann. MUSIC "The Most Beautiful Girl in the World," by Prince. SOUND DIRECTION Mike Iveson. VIDEO Charlotte Cullinan

Hot Heap and Plether
Die Pratze, Tokyo (July)

2001
Prelude to Fawn
Brooklyn Arts Exchange, New York (January)

I'm in Fawn
The Kitchen, New York (February 7–10), part of the series Talking Dance, organized by DANCENOISE. CHOREOGRAPHY in collaboration with Mike Iveson and Tanya Uhlmann

Group Experience
P.S. 122, New York (October). Traveled to Zürcher Theater Spektakel, Zurich (August 2002). PERFORMERS Nancy Alfaro, Miguel Gutierrez, Mike Iveson, Parker Lutz, Michelson, Glen Rumsey, Tony Stinkmetal, Cheryl Therrien, and Tanya Uhlmann. (Tracey Morgan, Adrienne Truscott, and Greg Zuccolo replaced Alfaro, Gutierrez, and Lutz for several performances.)

2002

The Experts

White Oak Dance Project, Jacksonville, Florida (March). Traveled to Jacob's Pillow Dance Festival, Becket, Massachusetts (June 19–23). PERFORMERS Miguel Anaya, Mikhail Baryshnikov, Emily Coates, Jennifer Howard, Roger C. Jeffrey, Sonja Kostich, and Rosalynde LeBlanc. MUSIC Mike Iveson. COSTUME DESIGN Michelson and Tanya Uhlmann

Grivdon at the Grivdon Concrete

The Kitchen, New York (April 19–20), part of the series Two on Two [2/2]. PERFORMERS Mike Iveson, Parker Lutz, Michelson, Tony Stinkmetal, Tanya Uhlmann, and Greg Zuccolo

Grivdon at the Grivdon Lawn

Jacob's Pillow Dance Festival, Becket, Massachusetts (June)

ONE NIGHT ONLY THE WHEATLY BALLET

Lexington Arts Center, Lexington, New York (June)

Dancing

Danspace Project at St. Mark's Church, New York (October)

2003

NGE

Movement Research at Judson Church, Judson Memorial Church, New York (January)

The Apartment

857 Fifth Avenue, New York (February). PERFORMERS Michelson and Greg Zuccolo

Shadowmann

Part 1: The Kitchen, New York (March 27–29 and April 1–5). Part 2: P.S. 122, New York (April 9–13, 16–20, and 23–27). Traveled in 2004 to the Cutting Edge Festival, Frankfurt (June); SommerSzene, Salzburg, and the Biennale Danza, Venice (July); and the Zurich Theatre Spektakel Festival and Tanz im August, Berlin (August). CHOREOGRAPHY in collaboration with Mike Iveson, Parker Lutz, Tanya Uhlmann, and Greg Zuccolo. PERFORMERS Henry Baumgartner, Greta Quinn Feit, Jennifer Howard, Mike Iveson, Jm Leary, Parker Lutz, Paige Martin, Michelson,

Dylan Page, Adrienne Swan, Emily Turco, Tanya Uhlmann, Lucy Watson, Sacha Yanow, and Greg Zuccolo. LIGHTING DESIGN Jonathan Belcher and Frank DenDanto III. VISUAL DESIGN Michelson and Parker Lutz. MUSIC Mike Iveson with quotations from Cibo Matto, New Order, and Uriah Heep. VIDEO Mike Taylor. PRODUCTION DESIGN Frank DenDanto III

2005

Love Is Everything

Lyon Opera Ballet (May 17–21). ASSISTANT TO CHOREOGRAPHER Parker Lutz PERFORMERS Coralie Bernard, Fernando Carrión Caballero, Peggy Grelat Dupont, Yang Jiang, Caelyn Knight, Caroline Lhuillier, Ana Presta, Martin Roehrich, Jaime Roque de la Cruz, and Michael Walters. LIGHTING DESIGN Patrice Besombes. MUSIC Mike Iveson. VISUAL DESIGN Michelson with Parker Lutz. PORTRAITS Claude Wampler

Daylight

P.S. 122, New York (June 15–19 and 21–26). CHOREOGRAPHY in collaboration with Mike Iveson, Parker Lutz, and Greg Zuccolo. PERFORMERS Lindsey Fisher, Mike Iveson, Parker Lutz, Michelson, and Greg Zuccolo. "ICE FLOWERS" written and performed by Howie Statland, danced by Lindsey Fisher. LIGHTING DESIGN Joe Levasseur and Michelson. LIGHTING DIRECTOR Carrie Wood. MUSIC Mike Iveson. With Tony Brown (vocals), Dave Geist (electric bass), Matt Rocker (keyboards), Sean Sonderegger (saxophone), Howie Statland (band leader and guitar), Mike Pride and Max Tucker (drums), and Gina Vetro (piano). ARCHITECTURE Dominic Cullinan. VISUAL DESIGN Parker Lutz and Michelson. CARPENTRY Kyle Kennedy and Cheda with Johnny Rus, DJ, Carmine, and Katrina. SET DECORATION Andrew Fassel, Marti Weithman, and Suzi Silbar. PORTRAITS Claude Wampler. PROJECT DIRECTOR Barbara Bryan. TECHNICAL DIRECTOR (P.S. 122) Derek Lloyd. PRODUCTION MANAGER Davison Scandrett. ADMINISTRATIVE ASSOCIATE Nora Painten

Daylight (for Minneapolis)

Walker Art Center, Minneapolis (September 15–18). Traveled, as Daylight (for Seattle), to On the Boards, Seattle (October). CHOREOGRAPHY in collaboration with Jennifer

Howard, Mike Iveson, Parker Lutz, and Greg Zuccolo. PERFORMERS Dustin Bailey, Cole Clemens, Nora Dahlberg, Bethany Deline, Rebekah Doron, Kayleen Downing, Lindsey Fisher, Kasey Greer, Bekah Gudim, Nor Hall, Mary Harding, Catherine Hawk, Orlaith Heymann, Laura Hild, Grace Holden, Alicia Houston, Jennifer Howard, Mike Iveson, Anne Jeffries, Chloe Jensen, Hayley Jensen, Andrea Jones, Martha Koch, Grace Lanz, Pat Leefeldt, Joe Lemien, Sarah Licari, Parker Lutz, Jennifer Maiers, Amelia Mattson, Kelsey McGowan, Michelson, Ruby Myers-Wilkes, Katie Nelson, Heather Ostendorf, Amanda Pearce, Amy Peppe, Kristen Sachwitz, Jessica Slagle, Christel Sorg, Lauryn Stockman, Katie Strot, Colleen Sullivan, Maggie Sullivan, Calie Swedberg, Erin Tope, Emily Vaughan, Tara Weinberg, Emily Winkler-Morey, and Greg Zuccolo. "ICE FLOWERS" written by Howie Statland, sung by Matt Rocker, danced by Lindsey Fisher. LIGHTING DESIGN Joe Levasseur and Michelson. Additional lighting by Ben Geffen and Davison Scandrett. MUSIC Mike Iveson. With Tony Brown (vocals), Pete Hennig (drums), Cody McKinney (bass), Clay Pufahl (saxophone), and Matt Rocker (band coordinator, guitar, and keyboard). ARCHITECTURE Dominic Cullinan. VISUAL DESIGN Parker Lutz and Michelson. PORTRAITS Claude Wampler. PORTRAITS AND SET DETAILING (MINNEAPOLIS) Mayme Donsker, Karl Friedrich, Hannah Hall, Mario Martinez, Patrick Moen, Joe Nixon, Creighton Penn, Meghan Smith, Charles Spitzack, and Kirsten Swank with guidance from Claude Wampler. PROJECT DIRECTOR Barbara Bryan. PRODUCTION MANAGER Davison Scandrett. ADMINISTRATIVE ASSOCIATE Nora Painten. PRODUCTION AND COSTUME ASSISTANT Laura Raban

2006
Swan Lake
Transitions Dance Company at Laban Theatre, London (May 3–5). PERFORMERS Alice Downing, Matthew Howells, Annarita Mazzilli, Marc Melvin, Katja Nyqvist, Adham Saad, Lisa Stefani, Laura Weston, Jessica Williams, and Joo-Hee Yang

DOGS
Harvey Theater, Brooklyn Academy of Music (October 18–21). Traveled to Hebbel Theater, Berlin, as part of the festival Tanz im August (August 2007). CHOREOGRAPHY in collaboration with Jennifer Howard, Parker Lutz, and Greg Zuccolo. PERFORMERS Henry Baumgartner, Alice Downing, Jennifer Howard, Parker Lutz, Michelson, Laura Weston, and Greg Zuccolo. COSTUMES Deanna Berg. Additional costumes by Deborah Thomas, on loan from Transitions Dance Company at Laban Theatre. LIGHTING DESIGN Michelson and Davison Scandrett. Influenced by Patrice Besombes and Ross Cameron. SOUND DESIGN James Lo. MUSIC Mike Iveson. VISUAL DESIGN Parker Lutz and Michelson. NEON CONSTRUCTION Matt Dilling, Litebrite Neon Studio. SCENIC ELEMENTS CONSTRUCTION Cavan Jones and Davison Scandrett. Further scenic construction by Robert Strahan of Robert Strahan Custom Woodworking. TECHNICAL DIRECTOR Davison Scandrett. PRODUCER AND MANAGER Barbara Bryan. PRODUCTION SUPERVISOR AND STAGE MANAGER Will Knapp

2008
Dover Beach
Chapter Arts Centre, Cardiff, Wales (September 3–6). PERFORMERS Latysha Antonio, Gwenllian Davies, Alice Downing, Georgina Glover, Non Griffiths, Mike Iveson, Laurie-Anne Kemlo, Lauren Walsh, and Laura Weston. MUSIC Pete Drungle. POEM "Dover Beach," by Matthew Arnold. VISUAL DESIGN Parker Lutz and Michelson

2009
Dover Beach The Kitchen
The Kitchen, New York (June 9–13). PERFORMERS Latysha Antonio, Oren Barnoy, Sofia Britos, Alice Downing, Non Griffiths, Allegra Herman, Jmy Leary, Adele Nickel, James Tyson, Rebecca Warner, Laura Weston, and Greg Zuccolo. COSTUMES Deanna Berg MacLean and Elena Scelzi. BUNS Jmy Leary. LIGHTING DESIGN Michelson and Carrie Wood. ASSISTANT LIGHTING DESIGN Emily McGillicuddy. MUSIC Pete Drungle. With Samuel Blais (woodwinds), Stephanie Griffin (viola), Okkyung Lee (cello), Christopher McIntyre (trombone), Charlotte Pharr (vocals), and Hiroko Taguchi (violin and viola). POEM "Dover Beach," by Matthew Arnold. SURROUND MIX AND ADDITIONAL SOUND DESIGN Max Bog-

danov. VISUAL DESIGN Parker Lutz and Michelson. NEON LIGHT DESIGN Charlotte Cullinan. HEAD CARPENTER Elliot Howell. HEAD RIGGER David Powell. HEAD PAINTER Francesca Soroka. TECHNICAL DIRECTOR Rory Mulholland

2010
The Hangman
Candoco Dance Company, London (March 3–April 29). COSTUMES Michelson and Debbie Thomas. LIGHTING DESIGN Michelson and Chahine Yavroyan. MUSIC Pete Drungle

2011
Devotion
The Kitchen, New York (January 14–16 and 19–22). Toured to the Walker Art Center, Minneapolis (February 17–19), ODC Theater, San Francisco (March 4–6), and On the Boards, Seattle (March 10–13). CHOREOGRAPHY for New York City Players. ASSISTANT TO THE CHOREOGRAPHER Alice Downing. PERFORMERS Jim Fletcher (Adam), Non Griffiths (Mary), Eleanor Hullihan (Eve), Nicole Mannarino (Spirit of Religion), James Tyson (Jesus), and Rebecca Warner (Narrator). "PROPHETS" Alice Downing, Liz Jenetopulos, Nancy Kim, and Neal Medlyn. COSTUMES James Kidd, Michelson, and Shaina Mote. LIGHTING DESIGN Michelson and Zack Tinkelman. MUSIC Pete Drungle. Additional music: "Dance IX," by Philip Glass. TEXT Richard Maxwell. PAINTINGS TM Davy. FITNESS COACH AND MASSAGE THERAPIST Sulyn Silbar. PRODUCTION MANAGER Bozkurt Karazu. MANAGER Barbara Bryan

2012
Devotion Study #1—The American Dancer. Balanchine: Superficial Europeans are accustomed to say that American artists have no "soul." This is wrong. America has its own spirit—cold, crystalline, luminous, hard as light. . . . Good American dancers can express clean emotion in a manner that might almost be termed angelic. By angelic I mean the quality supposedly enjoyed by angels, who, when they relate a tragic situation, do not themselves suffer.
Whitney Museum of American Art, New York (March 1–11), part of the 2012 Whitney Biennial, organized by Jay Sanders and Elisabeth Sussman. PERFORMERS Kira Alker,

Maggie Cloud, Charlotte Cullinan, Moriah Evans, Eleanor Hullihan, Nicole Mannarino, and James Tyson. COSTUMES James Kidd and Michelson. TAILORING A. Halford, Martin Morse, and Shaina Mote. HAIR Jmy Leary and Alice Downing. SOUND DESIGN AND SOURCING James Lo and Michelson. TEXT Richard Maxwell. VISUAL DESIGN Michelson. LIGHTING DESIGN Michelson and Zack Tinkelman. FLOOR DESIGN Michelson and Zack Tinkelman. NEON LIGHT Charlotte Cullinan, Parker Lutz, and Michelson. CONSTRUCTION Bob Bellrue, F. P. Boué, Jörg Jakoby, Rory Mullholland, and Zack Tinkelman. PRODUCING DIRECTOR Barbara Bryan. PRODUCTION MANAGER Bob Bellrue. ADMINISTRATIVE ASSOCIATE Julie Alexander. PERFORMANCE ASSISTANT (WHITNEY BIENNIAL) Greta Hartenstein. RIGHT HAND Zack Tinkelman. INTERNS Kira Alker and Buck Wanner

Not a Lecture/Performance
Tinker Auditorium, New York (October 12), part of the festival Crossing the Line, organized by the French Institute Alliance Française

Devotion Study #3
The Museum of Modern Art, New York (November 2–4), part of the series Some sweet day, organized by Ralph Lemon, Jenny Schlenzka, and Jill A. Samuels. PERFORMERS Nicole Mannarino and James Tyson. GUARDS Tyrese Kirkland and Gary Levy. COSTUMES Alice Downing, Jmy Leary, and Michelson. LIGHTING AND PRODUCTION Zack Tinkelman. PRODUCING DIRECTOR Barbara Bryan. ASSISTANTS Kira Alker, Oren Barnoy, and Alice Downing. INTERN Liz Young

2014
4
Whitney Museum of American Art, New York (January 24–26 and January 29–February 2). PERFORMERS Rachel Berman (Holy Spirit), John Hoobyar (Adam), Nicole Mannarino (Holy Spirit), James Tyson, and Madeline Wilcox (Eve). NARRATOR Rachel Berman. COSTUMES Michelson. HOODIES, PATTERNED PIECES, AND INITIAL SEAT PROTOTYPE Charlotte Cullinan and Jennifer Sims. LIGHTING DESIGN Michelson and Zack Tinkelman. NEON LIGHT Charlotte Cullinan, Parker Lutz, and Michelson. MUSIC Michelson. Additional music: "Dance IX," by Philip Glass. AUDIO

ENGINEER Andrya Ambro. AUDIO CONSULTANT Jim Toth. TEXT Richard Maxwell. VISUAL DESIGN Michelson, Greta Hartenstein, Jay Sanders, and Zack Tinkelman. SCREENPRINTER Winter Water Factory. CONSTRUCTION Jörg Jakoby, Timothy Lee, Rory Mullholland, and Jony Perez. MASSAGE THERAPIST Sulyn Silbar. PRODUCING DIRECTOR Barbara Bryan. PRODUCTION MANAGER Sarah Holcman. REHEARSAL ASSISTANT Eryk Aughenbaugh

Value Talk #6
Studio Five, New York City Center (May 14), part of the series Value Talks, organized by Ralph Lemon for The Museum of Modern Art's Artist Research Residency Program. PERFORMERS Rachel Berman, Nicole Mannarino, and Michelson

2015
My Name Is Beautiful Diamond
Whitney Museum of American Art, New York (July 22), part of the exhibition *DANCE-NOISE: Don't Look Back*, organized by Jay Sanders. PERFORMERS Rachel Berman, Danielle Goldman, John Hoobyar, Jennifer Lafferty, Nicole Mannarino, Michelson, Madeline Wilcox, and Greg Zuccolo

tournamento
Walker Art Center, Minneapolis (September 24–27). PLAYERS Rachel Berman (for Hawaii), John Hoobyar (for Oregon), Jennifer Lafferty (for Southern California), and Nicole Mannarino (for Ohio). TEAMSTERS Sjournee Cornelius-Quaidoo and Isabel Theobald (Hawaii), Aliseea Harwood and Margaret Skelly (Ohio), Vivian Fowler and Catherine Young (Southern California), and José Baltazar and Evin Schultz (Oregon). ADJUDICATORS Madeline Wilcox (Wilcox), Danielle Goldman (Goldman), and James Tyson (Tyson). TABLE ASSISTANTS Destiny Anderson and Alexandria Heide. ROUND-CARD GIRL Prudence Rusch. SCRIBES Kayla Bobalek, Rebecca Capper, Rebecca Ganellen, Maddie Hopfield, Leigh Taylor, Joanna Warren, and Anna Witenberg. COSTUMES Rachel Berman. JUMPSUIT DESIGN Bureau for the Future of Choreography, New York. MUSIC Michelson. VIDEO Mike Taylor and Michelson. VJ CUBES Kevin Zhu. DAILY GROUP TRAINING Nicole Mannarino. PRODUCTION Barbara Bryan,

Michelson, Zack Tinkelman. ADVISOR James Tyson. ADMINISTRATIVE ASSISTANTS Rachel Berman and Madeline Wilcox

For James Tyson
The Kitchen, New York (November 20). PERFORMERS Rachel Berman, Moriah Evans, John Hoobyar, Jennifer Lafferty, Nicole Mannarino, Michelson, and Madeline Wilcox. PRODUCTION Barbara Bryan, Michelson, and Zack Tinkelman

SELECTED BIBLIOGRAPHY

Interviews

Harrell, Trajal. "Sarah Michelson Interview." *Movement Research Performance Journal*, no. 40 (2012): 20–23.

Kourlas, Gia. "*Blister* in the Sun: Two Choreographers Take On the Elements—in the Buff." *Time Out New York*, April 6, 2000, 91.

———. "Go Your Own Way." *Time Out New York*, November 1, 2001, 79.

———. "Double Trouble." *Time Out New York*, March 27, 2003, 73.

———. "Sarah Michelson: The Award-Winning Choreographer Presents *Dover Beach* at the Kitchen," *Time Out New York*, June 2, 2009.

———. "Sarah Michelson: The Whitney Biennial Is the Setting for a Closer Look at *Devotion*." *Time Out New York*, February 21, 2012.

———. "Sarah Michelson Talks about Her Latest Premiere." *Time Out New York*, January 16, 2014.

Lemon, Ralph. "Sarah Michelson." *Bomb*, no. 114 (Winter 2011): 88–95.

O'Connor, Tere. "Sarah Michelson in Conversation with Tere O'Connor." *Critical Correspondence*, September 19, 2006, https://movementresearch.org/critical-correspondence/blog/wp-content/pdf/Sarah_Michelson_9-19-06.pdf.

Velasco, David. "1000 Words: Sarah Michelson Talks about *Dover Beach*, 2009." *Artforum*, May 2009, 214–17.

Exhibition Catalogues

Court, Paula. "On *Devotion Study #3* and *Devotion Study #4*, the Experience of Sharing an Artist and Work between Institutions: A Portfolio." In *On Value*, edited by Triple Canopy and Ralph Lemon, 198–208. New York: Triple Canopy, 2015.

La Rocco, Claudia. "Dear Sarah, Dear Ralph." In *On Value*, edited by Triple Canopy and Ralph Lemon, 186–97. New York: Triple Canopy, 2015.

Selected Newspapers and Periodicals

Acocella, Joan. "Mystery Theatre: Downtown Surrealists." *New Yorker*, August 8, 2005, 94–97.

Anderson, Jack. "Repression, Romanticism and Rebirth." *New York Times*, November 25, 1993.

Asantewaa, Eva Yaa. "Sarah Michelson's *Dover Beach*." *Dance Magazine*, June 16, 2009, http://dancemagazine.com/reviews/Sarah_Michelson/.

Bouger, Cristiane. "Sarah Michelson's *Dover Beach*: Translating Dance Concepts in the Process of Mastering a Form." *Movement Research Performance Journal*, no. 40 (2012): 24–25.

Boynton, Andrew. "Risking Rejection: Sarah Michelson Dances at the Whitney." *New Yorker*, March 8, 2012, http://www.newyorker.com/culture/culture-desk/risking-rejection-sarah-michelson-dances-at-the-whitney.

Burke, Siobhan. "Sarah Michelson's *Devotion*." *Dance Magazine*, January 15, 2011, http://dancemagazine.com/reviews/Sarah_Michelson/.

Carr, C. "Dancing About Architecture: For Sarah Michelson, the Environment Shapes the Work." *Village Voice*, April 9–15, 2003, 52.

Damman, Catherine. "Performance Review: *4*, by Sarah Michelson." *Women and Performance: A Journal of Feminist Theory* 25, no. 1 (January 2015): 107–9.

Dunning, Jennifer. "Cavorting in the Shower in Appropriate Costumes." *New York Times*, April 29, 2000.

———. "Are Those People Just Passing by or Part of the Act?" *New York Times*, April 4, 2003.

———. "Choreography That May or May Not Include a Cab." *New York Times*, April 14, 2003.

Goldberg, RoseLee. "Sarah Michelson's *Shadowmann*." *Artforum*, June 2003, 192.

Jowitt, Deborah. "Keep It Up." *Village Voice*, December 11, 2001, 65.

———. "House-to-House Sighting." *Village Voice*, April 9, 2003.

———. "Not a Home." *Village Voice*, June 14, 2005.

———. "She Can Dream, Can't She?" *Village Voice*, October 17, 2006.

———. "Sarah Michelson's Dark Tides." *Village Voice*, June 4, 2009.

———. "Sarah Michelson Teams Up with Richard Maxwell for *Devotion*." *Village Voice*, January 19, 2011.

Kinetz, Erika. "Sarah Michelson Makes Her Brooklyn Academy of Music Debut." *New York Times*, September 10, 2006.

Kisselgoff, Anna. "Eclecticism and an Aura of Uncertainty." *New York Times*, June 27, 2002.

Kourlas, Gia. "Movement Leavened with Language." *New York Times*, January 28, 2001.

———. "A Nonconformist with a Free-Flowing Fantasy." *New York Times*, August 25, 2002.

———. "Serious Choreography for Whitney Biennial." *New York Times*, February 25, 2012.

La Rocco, Claudia. "A Relentless Wave Rolls In with an Inevitable Power." *New York Times*, June 12, 2009.

———. "Matters of Faith, Prayer and Physical Exertion." *New York Times*, January 15, 2011.

———. "Managing to Change the Mood in MoMA's Atrium." *New York Times*, November 5, 2012.

———. "Four on the Floor." *Artforum*, February 5, 2014, http://www.artforum.com/slant/id=45152.

———. "Game On." *Artforum*, October 2, 2015, http://www.artforum.com/slant/id=55245.

Laub, Michael. "Strong Dancers: Sarah Michelson." *Ballet-Tanz*, July 2003, 18–21.

LeFevre, Camille. "Sarah Michelson's *Daylight (for Minneapolis)*." *Dance Magazine*, March 27, 2013, http://dancemagazine.com/reviews/Sarah_Michelson/.

Lepecki, André. "Choreopolice and Choreopolitics." *TDR: The Drama Review* 57, no. 4 (Winter 2013): 13–27.

Macaulay, Alastair. "Looking Inward, and Finding Inspiration." *New York Times*, January 27, 2014.

Mattocks, Aaron. "Dancing at the Whitney." *Hyperallergic*, March 20, 2012, http://hyperallergic.com/48661/dancing-at-the-whitney/.

Noyes, Katia. "God Bless Queer America." *San Francisco Sentinel*, March 1991, 27.

O'Donohoe, Casey. "Disinfecting Dixon Place." *Columbia Daily Spectator*, April 10, 2000, 9.

Perron, Wendy. "Is Appropriation the Same as Stealing and Why Is It Happening More Now?" *Dance Magazine*, October 11, 2011, http://dancemagazine.com/news/is_appropriation_the_same_as_stealing_and_why_is_it_happening_more_now/.

Reardon, Christopher. "Back on the Boards, but Haunted by an Injury and the Rent." *New York Times*, June 14, 2005.

Rockwell, John. "Elusive Meaning from Potent Movement." *New York Times*, June 17, 2005.

———. "Cats, Cooked Chicken and Abundant Ideas, but No Sign of Man's Best Friend." *New York Times*, October 20, 2006.

Seibert, Brian. "Five Figures Circling, Backward, across a Blueprint of the Whitney." *New York Times*, March 7, 2012.

Tyson, James. "The Institution and the Deep Blue Sea." *Movement Research Performance Journal*, no. 40 (2012): 27.

Velasco, David. "Dance: Best of 2009." *Artforum*, December 2009, 69–71.

———. "Sarah Michelson's *Devotion*." *Artforum*, March 2011, 270.

———. "A Room of Their Own: Three Views of the Whitney Biennial." *Artforum*, May 2012, 278–79.

———. "I'll Be Your Mirror." *Artforum*, January 2014, 170–79.

Wanner, Buck. "Taking Responsibility for Time." *Movement Research Performance Journal*, no. 40 (2012): 26–27.

Wechsler, Bert. "One's Company, but Watch Out for More Than One." *Attitude* 10, no. 1 (Winter 1994): 24.

Zimmer, Elizabeth. "Despondent Diva." *Village Voice*, December 28, 2004.

CONTRIBUTORS

Gia Kourlas was the dance editor of *Time Out New York* from 1995 to 2015 and has been a regular contributor to the *New York Times* since 2000. Her writing has appeared in *Dance Magazine*, *Dance Now*, *New York*, *Vogue*, *4Columns*, and many other publications.

Ralph Lemon is a New York–based writer, performer, visual artist, and choreographer.

Debra Singer is an art consultant, curator, and writer based in New York, where from 2004 to 2011 she was the executive director and chief curator of the Kitchen.

David Velasco is editor of artforum.com and a regular contributor to *Artforum*. He is the series editor for The Museum of Modern Art's collection Modern Dance.

Claude Wampler is an artist.

Greg Zuccolo is a performer and choreographer. His work has been presented at and supported by Yaddo, in Saratoga Springs, New York; Manhattan's Dixon Place; and JACK, in Brooklyn. He has collaborated with Joel Clark, Nicholas Elliott, Mike Iveson, Stanley Love, Sarah Michelson, Tere O'Connor, Tina Satter, and Ben Speth, among others, and continues to work closely with Michael Laub, creating and performing works internationally.

ACKNOWLEDGMENTS

Without the hard work, encouragement, and imagination of the following people, this book would have been at the very least impossible, certainly lesser.

Elizabeth Schambelan, Michelle Kuo, Tim Griffin, Charles Guarino, Tony Korner, Danielle McConnell, and Knight Landesman created the conditions for its earliest inklings, in stories cultivated in the pages of *Artforum*, a very special magazine and a unique place from which to write. A part of "Split City" was written for the January 2014 issue, under the leadership of Kuo and the immaculate steward-ship of Schambelan, incredible minds both.

Christopher Hudson, Chul R. Kim, David Frankel, Marc Sapir, Hannah Kim, and Genevieve Allison were among the marvelous thinkers and tinkerers in the Department of Publications at The Museum of Modern Art who carved a space for this book's existence, despite more than the usual number of obstacles. A special thanks to the book's editor, Rebecca Roberts, whose patience and clarity, grace and guidance were always completely and utterly right on.

Stuart Comer, Thomas J. Lax, and Ana Janevski are the superb wardens of MoMA's Department of Media and Performance Art and the book series Modern Dance. They are that lucky combination—exciting protagonists in the story of art *and* good friends.

I can't thank the writers for this volume enough: Gia Kourlas, Ralph Lemon, Debra Singer, Claude Wampler, and Greg Zuccolo, inspiring, devoted makers and intellectuals all.

The extended Michelson family was too generous in responding to my hapless inquiries: Philip Bither, Barbara Bryan, Paula Court, TM Davy, DD Dorvillier, Non Griffiths, Miguel Gutierrez, John Hoobyar, Jennifer Howard, Mike Iveson, Sri Louise, Parker Lutz, Matthew Lyons, Nicole Mannarino, Richard Maxwell, Dona McAdams, Eric McNatt, Julie Atlas Muz, Mark Russell, Jay Sanders, Zack Tinkelman, Adrienne Truscott, and Tanya Uhlmann, among them.

Scout McNamara and Katie and Mike Roeck provided perfect places for respite and reflection.

Without Douglas Crimp, Joey Teeling, Sarah Nicole Prickett, Samara Davis, Miriam Katz, Nikki Columbus, Claire Bishop, Yve Laris Cohen, Claudia La Rocco, Lynne Cooke, Sabine Rogers, Bruce Hainley, and Linda Norden, the thinking behind this book would be very small. Has anyone had such gorgeous interlocutors?

Designers Joseph Logan and Rachel Hudson took this thing and made it beautiful. Their way with artists and writers is nonpareil.

The book is part of the collection Modern Dance, which was made possible by MoMA's Wallis Annenberg Fund for Innovation in Contemporary Art through the Annenberg Foundation.

Glenn D. Lowry, Director of The Museum of Modern Art, is not just incredible at his job; he's a sharp-dressed man and a mensch. His commitment to art and its galaxies continues to astonish.

Kathy Halbreich, Associate Director and Laurenz Foundation Curator at The Museum of Modern Art, is more than those titles allow. She is a spell caster and dream weaver: she sees the future, and acts on it.

When people occasionally ask me, out of affection or doubt, why I continue to have faith in New York, I only have two words: Sarah Michelson. Working with her on this book was not just an honor; it also restored my sense that the joys of thinking and dancing emerge not from the desert of the self but from the spirit of being for each other. She gives everything. Is reciprocity possible, I wonder? No chance. But Michelson's uncompromising commitment to the work, to us, also demands that we try.

Thank you.

—David Velasco

For Kim, Ryan, Sam,
Kathy, Elizabeth, and Sarah